SECRET
BUDE

Dawn G. Robinson

AMBERLEY

Acknowledgements

A big thank you to Ray Boyd, as ever, for all his wonderful old photos, especially given his serious illness during the writing of this book. So glad Ray recovered; he is pure gold. Additionally, thanks to Malcolm Mitchell, Bob Willingham and the Westland Stewards for additional photos supplied.

The Bude & Stratton Heritage Centre archivists were a mine of suggestions and information, so huge thanks are also due to the volunteers there who gave up their time to assist.

A few dedications for people sadly lost to me during the course of writing this book:

David John Pritchard, aka, 'Pritch' (17 August 1964–20 October 2015), a friend who loved this town and became a 'Bude man'.

Stephen Alexander Robinson (9 February 1954–22 October 2015), my beloved and deeply missed big brother.

Donald Walsh, my father-in-law, himself an author, Oxford University engineer and grandfather to my five children Lexie, Laurence, Susie, Jeremy and Rosie Walsh – 22 February 1926 –16 December 2015.

First published 2016

Amberley Publishing
The Hill, Stroud
Gloucestershire, GL5 4EP

www.amberley-books.com

Copyright © Dawn G. Robinson, 2016

The right of Dawn G. Robinsonto be identified as the Author of this work has been asserted in accordance with the Copyrights, Designs and Patents Act 1988.

ISBN 978 1 4456 4529 2 (print)
ISBN 978 1 4456 4536 0 (ebook)

British Library Cataloguing in Publication Data. A catalogue record for this book is available from the British Library.

Typesetting by Amberley Publishing.
Printed in Great Britain.

Contents

1. Is Bude Really in Cornwall?

As Bude is the nearest town on the north-east coast of Cornwall to Devon, visitors often place it on the wrong side of the Tamar. I thought the rivalry between the two counties was overstated but this is an error of high magnitude, as a hapless gentleman in a local supermarket found to his cost, when he mentioned that Bude was in a lovely part of Devon. The collective audible gasp from shoppers in the queue led the cashier to gently correct him. So, while it is no secret, the first thing to know about Bude is that it is 100 per cent Cornish.

Although Cornwall's history is pre-Roman, Bude is Cornwall's 'New World', with little ancient history of its own, lying off the beaten track and relatively undiscovered until the 1800s, which makes it rather special. Not directly on a main road to anywhere (lying just off the A39 Atlantic Highway), Bude largely missed out on traditional Cornish industries like mining china clay and even, despite its coastal situation, large-scale fishing, though its beautiful seaside location did later, with the coming of the railway, appeal to tourists. There are no tin mines like there are in west Cornwall, a locality now depressed but which was once rather wealthy (such as the Gwennap Pit area, near Redruth, which even so remained without piped water and sewage systems until the 1960s).

Copper out towards Morwenstow, north of Bude, is rumoured to exist, but records are scant. Of course, no mines also meant that Bude escaped the worst of the depression of the 1860s when thousands of Cornish miners without employment emigrated. To digress slightly, this is one reason why the beloved Cornish pasty (held by tin miners by its thick-crust to avoid arsenic poisoning) can be found in Mexico; indeed, there is even a museum dedicated to the pasty in the Hidalgo area of Mexico, which is one up on Cornwall itself, although there are plans afoot to open one in St Austell. In Bude, we have a small number of shops selling pasties and, while you can now buy the ubiquitous meal anywhere in Britain, I still maintain they taste better in Cornwall, and to be authentic they must, of course, be made in the Duchy.

Legend has it that the Devil never crossed the Tamar into Cornwall because he wasn't brave enough to test the Cornishwomen's habit of putting *everything* into their pasties. A noble dish, it is said that Henry VIII's third wife, Jane Seymour, received a disconcerting note saying, 'Hope this pasty reaches you in better condition than the last one', which is seen as evidence that the Cornish pasty existed in 1537. We will never know what happened to 'the last one'.

Pasty rolled out like a plate,
Piled with 'turmut, tates and mate'.
Doubled up, and baked like fate,
That's a 'Cornish Pasty.'

Bude marker stone found alongside the Bude Canal.

So, Bude may not have had miners but it sure had pasties. Despite its location, it borrowed other things from the depths of Cornwall too, including nonconformist religious preferences. Wesleyanism, which took root in Cornwall among the pits, was led by John Wesley (1703–91), a talented and charismatic evangelist who was not afraid to tackle challenging social circumstances, often preaching to outdoor congregations in poor terrain; he was welcomed in the West Country, but intensely disliked by the established Church for bringing spiritual hope to the masses. After all, an emotionally charged 'underclass' was always going to be considered a threat to the perceived social order.

We must remember that living conditions for many families were shocking at this time, due to poor sanitation and poverty. Excessive drinking, fighting, and even rioting were commonplace among the miners, so the Temperance movement grew alongside Methodism to combat the social ills of heavy drinking. Bude was not exempt from this. There is said to have been a riot in Bude in 1899 which local artist Philip Jackson reckons has been 'airbrushed out of history'. The 'Launceston Then' website suggests that a man called Alfred Webber of Cornwall Constabulary, who lived in nearby Week St Mary from 1895, had to 'quell several disturbances with "navvies" that were engaged on the Halwill to Bude railway line'. Perhaps this was the 'rioting' of 1899?

Irish navvies used for canal work, and later railway building, were known for their heavy drinking (not unlike miners), so we can see why Methodism and Temperance appealed to Bude as much as other parts of Cornwall. However, the town also had its fair

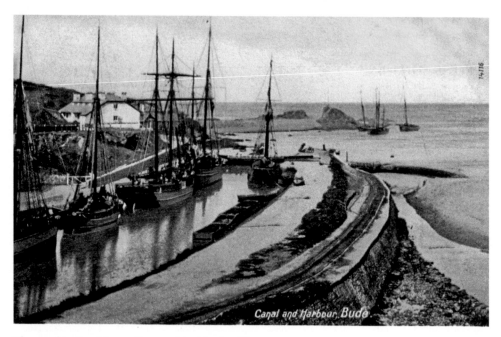

The canal in the 1880s – vibrant with shipping life.

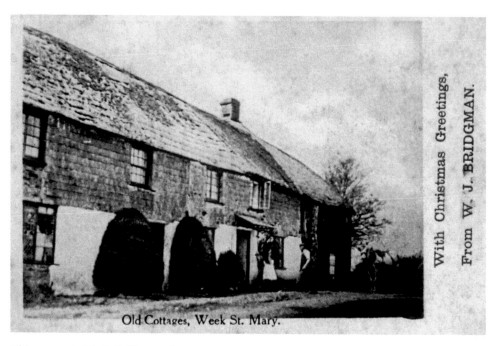

Old cottages in Week St Mary, early 1900s.

share of conformists who attended the established Church of England place of worship, St Michael's. It is a beautiful church overlooking the town, which I sadly only seem to visit for funerals, but well worth a look. Catholicism, incidentally, was the choice of but a small minority in Bude, with St Peter's Church near the Bencoolen, quite unattractively modern, built in 1926.

According to local historians Bere and Stamp (1980), the first Wesleyan meetings were held in Bude in 1820. Later an old building, a dwelling house, at the back of Lansdown Hill was used. By 1835, a second Methodist chapel was erected, called Villa Hall. Baronet Sir Thomas Acland, one of Bude's big property owners, provided two sites as Methodist chapels near Shalder Hill. One was Free Methodist (1879) and one Wesleyan (1880). It is the latter which still exists. So, in its heyday, Methodism marched quite quickly on in the town. It was the engagement with the marginalised and disenfranchised that appealed to the working people, but also meant that landowners were severely suspicious of it.

Bere and Stamp add that the first Methodist home in nearby Stratton was Molly Short's Cottage, close to Town Bridge on Hospital Road. Later, in Stratton, a man called Billy Hayman bought two houses in Fore Street which he converted into a chapel. The public outcry over this decision was so great that he was taken to court for 'violating his deeds'. This antipathy is hard for us to understand today but, in its heyday, Methodism truly rocked the status quo with its strong central organisation and lack of hierarchy. Billy won his case, though had to pay costs, and the chapel opened in 1805; others developed later. In everyday life, it was a case of never the twain shall meet as the different denominations barely spoke to each other at this time, even going so far as to buy their shoes in different

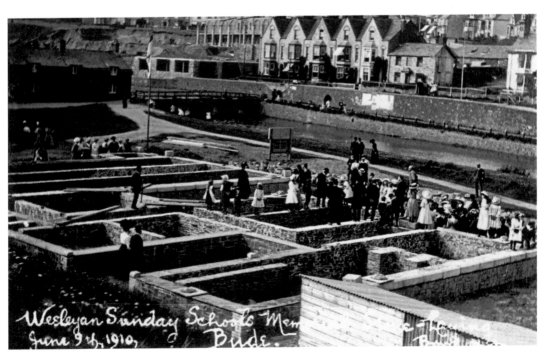

Foundations for the Central Methodist Sunday School, 1910.

shops. It is hard to imagine such overt religious divisions/segregation in Bude today, but they certainly existed in Stratton then.

Wesley visited Cornwall thirty-two times, the first in 1743, offering hope to all, rich or poor, through justification by faith. In 1851, according to Lord David Alton's blog, 32 per cent of Cornwall was Methodist compared to only 13 per cent in the established Church. Although there seems to be no record of Wesley ever visiting Bude itself, the Methodist belief system captured Bude's imagination. Some information suggests that Cornish Wesleyanism grew due to corrupt/dormant Anglicanism which had become remote from its people, and the massive social change accompanying industrialisation, though established-church attendance seemed higher in and around Bude than many other parts of Cornwall. Also, the sense of Celtic separation in Cornwall made anything questioning English 'supremacy' rather appealing. The Church of England was said to be failing in Cornwall as early as 1770, partly because of the self-indulgent nature of the clergy. However, equally important was the geography. Dispersed settlements, and remoteness of the gentry meant that social deference was not high on the Cornish agenda. Additionally, mining became a global market phenomenon, where local decisions were made according to external demands, impacting upon the whole region.

We cannot focus on mining to explain Methodism in Bude, but even now Bude seems to have a bottom-up approach to power, with a good number of participatory, active citizens within a proactive community, so maybe the democratic ethos simply appealed to the people the town attracts. Additionally, Methodism was simply in vogue at the time. David Luker suggests that 'for the poor, Methodism did not principally legitimate "respectable" or middle-class values; it legitimated the morality and structures of "traditional" Cornish society'.

Interestingly, given neighbouring Stratton had a glut of pubs and inns, Bude had a number of Temperance establishments, so was also linked with the abstinence of nineteenth-century Methodism which (probably rightly) linked poverty and violence to drunkenness and strong liquor. Bude and Stratton may be close and they may be Cornish, but even they have strong differences.

Fishing, another traditional Cornish industry, was also difficult to sustain in Bude. The coast here is rough, and rugged and even the harbour is difficult. Bude was thus known less as having a sustained fishing industry than for the locals opportunistically grabbing shoals of mackerel and pilchards whenever they appeared. At such times, even farmers and labourers would take to the sea to maximise their chances of finding food. There was just enough fishing in Bude to maintain some fish cellars at Efford. Other nearby industries included the exporting of garlic from Stratton, a local-sheep-based woollen industry at Week, Jacobstow and Poundstock, and tanning. So, Bude missed out on the big-scale industries, but similarly, it also missed out on the decline of these, which has now left some Cornish towns looking sadly depleted and impoverished. Later, it was able to work with the waves to become a key surfing Mecca.

Bude by the sea, of course, is a fascinating town, with an historically mixed community of locals and people from 'up country'. It is closely linked to seafaring, wrecks, the canal, the railway and tourism. Additionally, it is central to a cluster of outlying villages and hamlets in North Cornwall, home to many tales (some grisly) including a murder in

The Black Scorpions from the Methodist Youth Club.

Wild garlic, found by Bude Canal, but also prolific in Stratton.

Poundstock Church, which could almost rival Becket. It has, given it is a small seaside town, attracted many interesting visitors, not least Tennyson, a descendent of Tolstoy, and tarot artist Pamela Colman-Smith, who lived and died, though was not buried, here. Bude was even home to a lookout on the *Titanic*; Archie Jewell was a *Titanic* survivor which, in itself, is remarkable.

Bude really connected with other areas when the construction of the canal brought in workers, and brought in holidaymakers later when the railway opened in 1898. Only sixty-eight years later, the railway closed. 1966 was quite a year: England may have won the World Cup 4-2, triumphing against the German team, but Bude's railway also closed, which probably had a far greater local impact. We have never won the World Cup a second time, nor has Bude ever regained its railway. Only recently the Bude Heritage Centre purchased a collection of superb artefacts pertaining to the old Bude railway station. The loss of the railway was down to the chairman of British Rail, Dr Beeching. His commission was simple: 'make the railways pay'. His report of 1963 advocated slashing the railways, a policy which was later executed on a huge scale that included Bude.

Much as the memory of Beeching is distasteful, one must remember that British Rail was losing £140 million a year when he took over. Massive cuts were his rather predictable answer, but rural communities, not least Bude, reeled from the loss of branch lines when he closed 2,000 railway stations. A BBC website suggested that the tragedy of Beeching's cuts was the loss of 9,000 miles of 'superbly engineered right of way'. This certainly occurred in Bude. Despite passionate calls for a new railway, the tracks and land have been lost forever, and a return of the railway is extremely unlikely, with the nearest likely

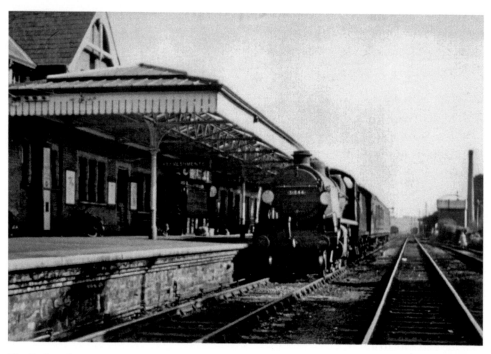

The Bude railway station, 1960.

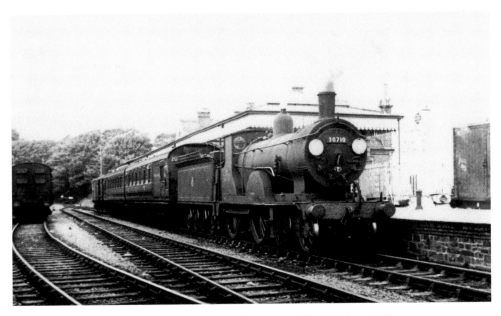

Railway engine, Bude. T9 Class 4-4-0, No. 30710 (courtesy of Malcolm Mitchell).

to be Okehampton, around 28 miles away, to connect to the mainline at Exeter. Failing to think outside the box simply meant slashing the infrastructure. Never have the words 'once gone, gone forever' been truer. It seems absurd that it is now harder to reach Bude by public transport than it was in the nineteenth century, but it's true. Many locals hope for a return to some nearby railway provision, especially as the current rail route into Cornwall from the rest of England is via the precarious line at Dawlish in south Devon, which is subject to the will of the tides and storms, but progress is slow.

The Milk Train to Bude

The artefacts at the Bude Heritage Centre include many from the old railway station, but also include a fascinating collection of handwritten accounts of shipwrecks, from *Capricornia* to the *Bencoolen*. The coast is indeed treacherous, which explains why the canal was built in an attempt to avoid sailing much of it. So, hidden in the archives of The Castle (free entry) lie many fascinating documents that the town council is currently trying, through its dedicated team of volunteer archivists, to make available to the public. If visiting Bude, make this your starting point when checking out the history and geology.

Speaking with local volunteer archivist Pearl Myers, it seems that many local people still have fond memories of the railway. The late Bryan Dudley Stamp told wonderful tales of his visits to Bude from London, including dining in style on the train. Pearl's family used to catch the milk train from London Waterloo at 1 a.m., which would arrive at Bude at 8 a.m. to a view of the gas cylinders. One morning, the train ground to a halt as there was a cow on the line. It is the stuff memories are made of. Her grandfather would

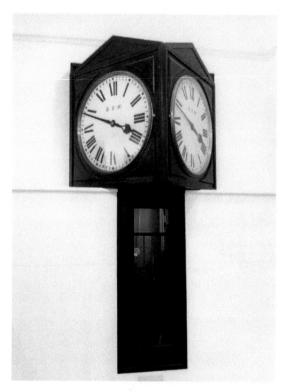

Bude station clock, artefact in the heritage centre at the Castle.

also bring a suitcase full of disguises, which they would wear when travelling so other people would not sit in their carriage.

Pearl's family would come to Bude on holiday, though they actually stayed out at Welcombe, just into Devon – Bude was the nearest station. They saw a place advertised in the *New Statesman*, West Mill, based at Marsland Mouth. It was an old mill with electricity that only worked if the mill wheel was turning. Pearl's family stayed there many years, her first visit being in 1955 when she was ten. It belonged to Ronald Duncan, the playwright, who was born in 1914 in what is now Zimbabwe and who died in Barnstaple in 1982, and bought the lease to West Mill in 1937. He is said to have lived as a pacifist at Mead Farm, near Welcombe, during the Second World War, but to achieve literary fame he developed increasing links with London. His guests at West Mill included luminaries like Benjamin Britten, and T. S. Eliot. In Duncan's autobiography *How to Make Enemies* he wrote of Bude:

I knew Bude when it was a pleasant seaside village consisting of little more than a few cottages adjoining the 'Carrier's Inn' which still stands opposite the canal. But then it developed; a large cinema was built on the top of the hill in the best Babylonian style of the 1930s. This cinema is now almost empty, due to a resident of Bude whom I used to see in the town during the war: his name was John Baird. He invented television. I doubt if Bude even knows he was a resident, though there is a monument on every rooftop in the town to him." Now Bude – or rather Poundstock – is home to a small independent two-screen cinema called The Rebel. It is like cinema used to be and well worth a visit.

Bude Gas Works, which could be seen from the railway.

Scot, John Logie Baird, who died at the age of 57 in 1946, was evacuated to Bude during World War II. Baird was a socialist, appalled by the grim poverty he regularly witnessed in Glasgow. The stereotypical absent-minded inventor, he also apparently hated getting his hair cut. His daughter, Diana Richardson, wrote: 'One day he was sitting on a cliff top in a deckchair when he was arrested by a military policeman: the strange figure with his black astrakhan overcoat and long hair, writing busily in a notebook, looked suspicious. My mother bailed him out by showing his ration book!'

Pearl said that catching the train from the house in Welcombe was the only time they came into Bude as they used the village shop and had no car. They would get a taxi from the railway station to the place they stayed. The nearest 'shopping centre' was Hartland, where there were then three butchers. They could order groceries over the telephone to be dropped off at the end of the round. On the last day of the holiday, it would be back to Bude to get the train to London. If only it was so easy now, Dr Beeching.

While Bude is a relatively modern development as towns go, it has packed a good deal into its short life as a community. Previously, the 'furzy down' off the beaten track was a place cut off from the bustling, more important proximate town of Stratton because there was nothing there and nowhere to go. Transport links would also have been exceptionally poor, as it involves a turn off from the main A39 Atlantic Highway which is still often nothing like an 'A' road in places. The coast was treacherous. Why would you willingly go there? Stratton, meanwhile, was bustling, awash with pubs, trade, religion and even 'the clink' for miscreants. Bude does not have the far-reaching history that incorporates Romans and Vikings. The secret aspects range from smugglers' caves to modern tales, but what is no secret about Bude is that it is a very real community; people take time to talk and to help each other here.

Perhaps the first thing to explain about Bude's physical structure is that it is divided in two by the River Neet, which mirrors the original divided ownership of the town. You cross it on foot via Nanny Moore's Bridge or the Bencoolen Bridge at the far end of The Strand, or you go round the long way via the beach (at low tide) or the one-way road network.

Who Owned Bude?

Almost all of the built-up parts of Bude and Stratton were owned by two families: the Arundels of Trerice and the Grenvilles – families who were largely always on mutually good terms, who even intermarried. Sir Richard Grenville bought Binhamy Manor in 1576 and owned one side of the riverbank. The other side was owned by Lady Gertrude Arundel. Bude Bridge, now known as Nanny Moore's, was built, and Efford Mill (a tidal-salt watermill) was established.

The old mill cottage still stands, bearing the inscription 'AJA 1589' (Anne and John Arundel). So, what of Bude's two families? Both were Norman in origin, coming to England in the days of William the Conqueror, according to Stamp and Bere. Both were also staunchly loyal to the Crown. Testament to their status, the Grenvilles built a house

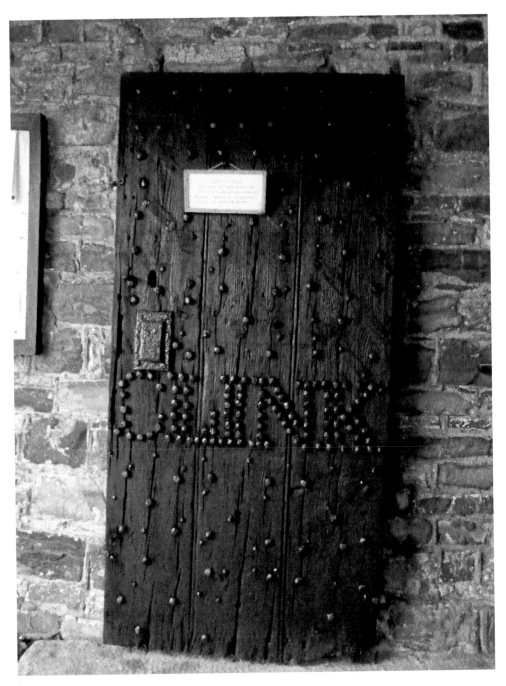

The door of the Clink, Stratton.

at Stowe, which was rather grand and, in fact, half a castle, but this was demolished in 1662, to be replaced by a large red-brick mansion which was controversially considered by some to be 'tasteless'. In 1739, it was pulled down by Grace, Countess Grenville. There are suggestions that it was demolished because of the window tax. Since then, the stables became a farmhouse (Stowe Barton) with appropriate curtilages. Imagine if we still had this as Bude's very own stately home.

The direct male line of the Grenvilles died out and the properties were passed to a kinsman, Henry Thynne, Lord Carteret. We still see the linked street names dotted around the town. The Thynnes built what is now the holiday village of Penstowe and remained at Kilkhampton until 1961. According to Stamp and Bere, the Thynnes were interested in the Port of Bude. Early on, in 1780, they leased off land at the Bewd Inn (Bude Hotel) on the site of the current TSB bank. Two warehouses were also built along the Strand, including Julia's Place (where the Strand arcade is) and on the site of the Strand Hotel. The Arundel lands included Efford Manor and Strand Farm, which were inherited by Sir Thomas Acland in 1802 who further developed Bude. The Aclands were of Saxon stock, originally settled in Landkey Parish, near Barnstaple – another Devonian influence on Cornish Bude!

The Aclands did a great deal for Bude including the creation of Efford Cottage from old fish cellars. Killerton Road, and Holnicote Road are both named after their houses situated in Exeter and Somerset. Sir Thomas Acland expressed interest in Bude as a seaside resort, so built Tommy's Pit, the bathing pool on the breakwater. His son Arthur placed the half-tide cross at the end of Coach Rock where Summerleaze meets Middle Beach; he also created the first tide tables. The Aclands also built the large red-brick Victorian mansion that became Efford Down Hotel. Acland housing developments included The Crescent and Breakwater Road.

They additionally granted that land could be used for Catholic and Congregational churches, founded Bude's primary school, and gave land for two nonconformist churches. St Michael's Church was also enlarged, for the Aclands were Anglican but very tolerant of other religious movements. The Thynnes, conversely, were strongly Anglican and never allowed a nonconformist church or chapel on their land. Both families strongly contributed to the development of the town.

By 1939, the Acland estates were sold off to pay for death duties. The council had already bought Summerleaze Down from the Thynnes who had sold off other land for a golf course. In 1940, the council was granted a 500-year lease on cliff land at Compass Point by the Acland Family.

Blanchminster Properties

The Blanchminster Trust is a charity which, according to a booklet by Kathleen Beswetherick (no date given) is probably named after a Knight Templar from the age of Edward I. He was called Blankminster and his effigy can be seen in a window embrasure in the wall of St Andrew's Church in Stratton. There are links with the Binhamy area of Stratton, too. Whatever its origins, the Blanchminster Trust is over 500 years old, so a

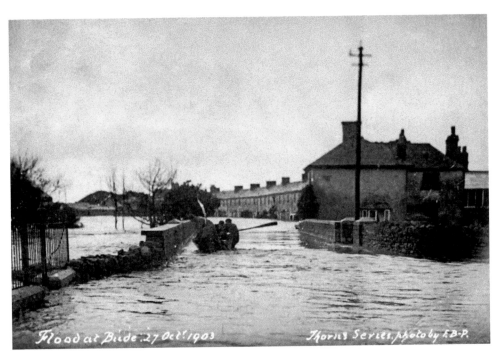

The flooded Crescent, Bude, 1903.

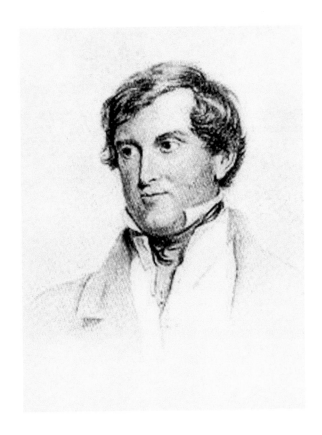

Sir Thomas Acland, one of the
leading developers of Bude.

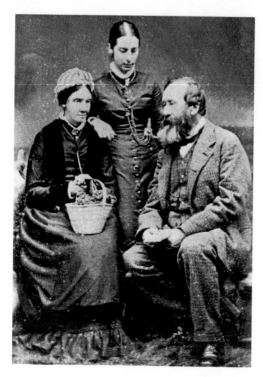

Thomas Dyke Acland with his wife and daughter, *c.* 1870.

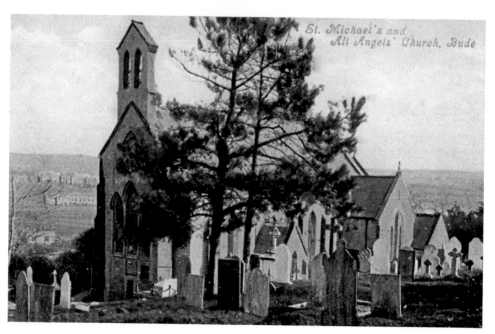

St Michael's Anglican Church, Bude, 1900.

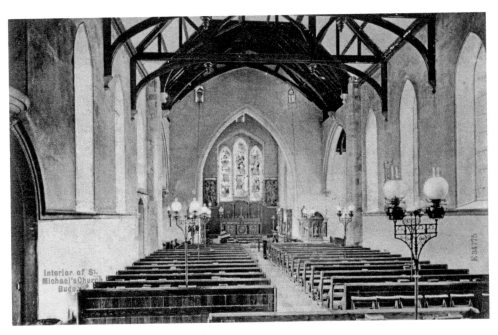

Interior of St Michael's Anglican Church.

very long-standing charity that quietly does a good deal of work on behalf of the people of Bude.

Pre-1744, the estates belonging to the charity were the responsibility of 'eight men of Stratton', used for buying armour and equipment of soldiers, relief and maintenance of the parish poor, and to defend the parish. The links were very much Stratton-based. By the end of the nineteenth century, there were a few misgivings about how it was managed. Criticisms included that Bude folk should not be compelled to go to Stratton for dole money, that Anglicans should not appear to have preferential treatment over nonconformists and that annual grants to church schools were subsidising the rates.

What is most interesting about the book is that, from an 1858 map, it lists parts of Bude properties held by the charity, shown together with lessees and occupiers. They include properties on what is now King Street, Lansdown Road and some parts of the Strand. Some buildings were on Tapson's Terrace, which now houses the Tiandi and other businesses. The Terrace was named after one Elsworthy Tapson who erected them as quality lodgings. In 1930, a disastrous fire in one of the shops, a ladies' outfitters, did £1,000 of damage to the building. The Globe Inn nearby was rebuilt in its present style in 1908 on the site of the Old Canal Inn. The current NatWest Bank there was formerly Bude's main post office. The present Barclays Bank used to be called Blanchminster House and was run as a hotel by the Edgecumbe family until 1925. The current police station was built in 1946.

In 1931, what was known as Garden Terrace became Lansdown Road. No. 21 was the London Inn (now occupied by Metters and Welby). The Lansdown Bakery is almost unchanged since 1921. A Mrs Ann Sampson held the tenancy and the place was renowned

Blanchminster building.

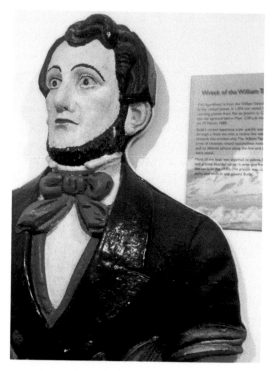

One of many wreck figureheads, this one from the *William Tapson*.

for her home-made biscuits. By the side of the shop is a doorway leading into a yard containing a building now used as a bakery. This was once a chapel seating sixty people. Around 1819, the lease of two cottages on this land was rented to Richard Bevan who pioneered Methodism in Bude, along with Samuel Brown. A description written in 1922 by Revd Schofield reads:

> Its walls were of mud, its roof thatched. Three of its sides were blank walls and there were but two windows to let in the daylight. A pupil was erected at one end and a small gallery for children at the other. The entrance to the Chapel was through a long, dark, narrow passage ... a stable was adjoining and oft times the services would be unceremoniously disturbed by the erratic movements and unreasonable pranks of the horse inside.

The building was used by the Wesleyans until 1835.

King Street was something of a problem for the charity. The houses (according to the 1889 accounts) when obtained were mainly dilapidated with no sanitary provision, so cost a considerable amount to repair. There were often complaints about these properties, such as in 1900 when a W. Wonnacott complained that the tenants were using his field (Sullivan's Meadow) to dry their clothes. Poultry also caused offence. No more than six hens were to be kept in any backyard, and no noisy cockerels. It was reported that ten people were living at No. 10, so the number was requested to be reduced. Morality also kicked in:

> In 1902, the Clerk was 'requested to write to a certain tenant stating that it is commonly reported that this tenant is harbouring a woman, not his wife, and is requested to immediately arrange for her to leave or his tenancy would be terminated'. I'm not sure if the man also had a wife, and if so, where he kept her!

Situated on some very spectacular coastline, Bude is known for wrecks; therefore, tales of the sea feature strongly. Like any town, it has its characters. To the casual visitor it seems like – and is – a pleasantly attractive, friendly family seaside resort. Yet even here, there are amusing tales to be told. For example, on 3 August 1998, Princess Anne visited Bude, wearing white trousers and loafers, having attended an Inter-Celtic water sports event. She made an unscheduled stop for a stroll on the beach, which, if it was anything like Bude normally is, had a fair few pools and rivulets to deal with. A young surfer, Johannes Schega, a ten-year-old visitor from Lindau in Germany, immediately put down his boogie board to keep the Princess's shoes dry in a move that would not have shamed Walter Raleigh, proving that chivalry is not dead in Bude.

Secret Bude will, hopefully, be an interesting read. It pertains to its history, but also its many legendary characters, and includes a chapter on contemporary Bude which remains unconventional, creative and environmentally aware; never did so small a population have so many artistic, creative and entrepreneurial people within, or at least that's how it often feels. Geographical isolation and curious geology somehow creates a sense of difference, so there are some interesting tales to tell. The community is vibrant and welcoming; it embraces innovation and difference – one reason why so many people from outside the area settle here so readily.

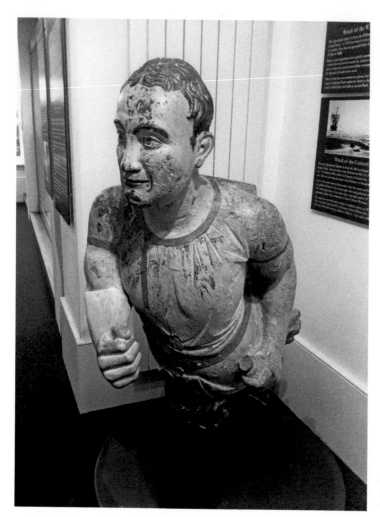

Another wreck figurehead from the Wreckers' Coast.

The big problem with tales from Bude is one of accuracy. There are so many local stories passed down through the oral tradition that they cannot be readily verified. So, if we disappear into seeming flights of fancy, bear with the tale and let your imagination soar. With this in mind, it's wise to take many of these local legends with a pinch of salt. If it's true, it's a bonus; if not, then it is still a good tale.

In writing *Secret Bude*, I've spoken with local people, read local books and websites, used social media, checked out the archives and enjoyed perusing the collection of information at the home of the late Bryan Dudley Stamp, a well-known local historian, who told me some wonderful stories when we met. I've also met one of his contemporaries, Tony Edwards, who has also been a gold mine of information about the mysterious Pamela Colman-Smith, so my thanks to them both.

2. Murderous Tales of Bude

The Iron Pineapple

We all love a mystery. Today, Bude is a benign place, but it has never been totally immune from the dark side of life. The town notably features in a fictional tale of the unexpected, drawn to my attention by the knowledgeable ladies of the local Heritage Centre at Bude Castle. In *Cornish Tales of Terror*, a tale called 'The Iron Pineapple' by Eden Philpotts – 1862–1960 and known as 'the Dartmoor Scribe' – gives an accurate description of Bude, or more specifically, nearby Flexbury. The 'Iron Pineapple' is a little-known tale of obsession that's worth retelling, described by its editor, R. Chetwynd-Hayes, as, 'a subtle piece of macabre, told with a certain amount of underlying humour, but at the same time portraying the horror of a mind possessed'. It is the tale of a character called John Noy, from Holsworthy (Devon), who moved to Bude and was the keeper of a small greengrocery shop and a post office. Noy struggled with obsessive-compulsive disorder (OCD) and would grow fixated by people, things, or events. In the tale, his obsession takes a dangerous turn when he develops an intense irrational dislike to a visiting artist and a railing ornament, leading to a grisly end for both. Obviously, the writer draws upon evidence from Bude in his tale, which is mainly what interests us here. He wrote of the rising district of Flexbury, on the north side of Bude, where 'new houses were springing up like mushrooms' while criticising their stability. He also observed that Bude was not like it was: 'Now an enormous summer population pours upon us annually, and the golf-links swarm with men and women ... and the wide sands of the shore are covered with children ... like pink and white flower-petals blowing over the sand when the tide is out.'

Noy was like a dog with a bone, becoming obsessed by specific things and people, such as the well-known, ill-fated *Bencoolen* shipwreck, wrecks generally and the graves of the dead. He notes how the Bencoolen's 'Asiatic chieftain' (whose figurehead is viewable in the Castle) held a mesmeric power of attraction for him: 'Indeed, I only escaped by abandoning the Church of England and joining the sect of the Primitive Wesleyans. I avoided the church and the grave of the drowned men ...' He described the (Methodist) chapel in Flexbury as 'a most debased form of architecture ever sprung from a mean mind' (although I find it rather pleasing, despite the rumour that its spire was inspired by a rude gesture).

The actual victim in 'The Iron Pineapple' is a large, bearded artist, said to be lacking talent, who would paint on Bude's sands, and for whom Noy conceived a violent dislike, or indeed, loathing. His dislike grew into 'an acute and homicidal hatred'. In the tale, the man sounded pleasant enough. He had a kind, good-natured face, laughing brown eyes and a genial voice, which only somehow served to increase Noy's antipathy. Noy began

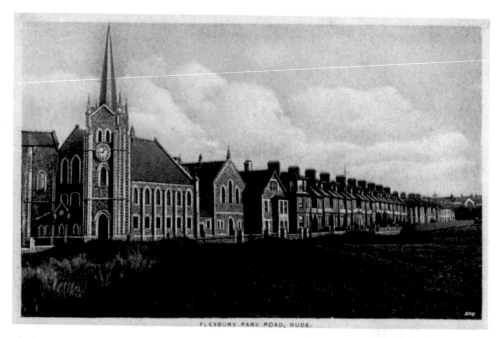

FLEXBURY PARK ROAD, BUDE.

Flexbury Park in the 1910s.

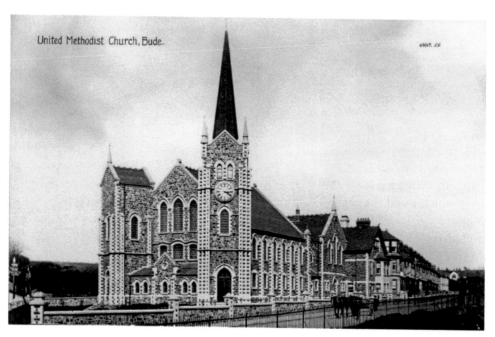

United Methodist Church, Bude.

Flexbury Chapel, 1905.

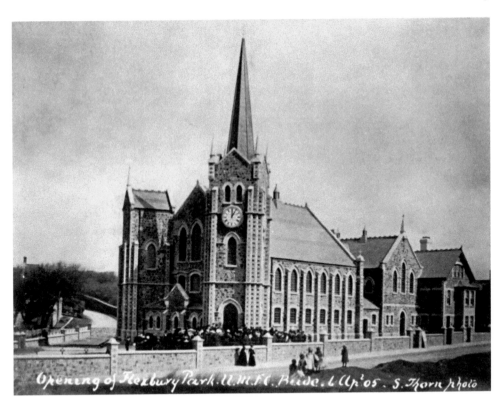

The opening of Flexbury Chapel.

to feel in need of medical help but rightly feared incarceration if he admitted to his dark, murderous fantasies.

Later, during some nearby housebuilding, he fixated on some fencing crowned with some (perceived vulgar) iron pineapples which he called 'vile things'. He became unduly attached to one that he would visit and stroke, while developing an all-encompassing desire for it, longing to have the pineapple with him, seeing it as a sentient, personified thing which could feel sorrow and grow cold. So one night he stole it, concealing the weighty 2-pound object in a drawer. A reward for the return of the offending object was offered by the owner of the Italianate house where it stood. Meanwhile, the deranged Noy would walk the cliffs and lanes, talking to the flowers and gulls, driving his wife to distraction too.

The author almost comically writes of Noy's trip to the cliffs with his pineapple, when he happens upon the artist singing a cheery song. He explained how, at lunch-time, the place would clear of golfers, bathers and families who would escape to eat. He realised how entirely Bude had become a pleasure resort, how absolutely it depended for prosperity among those who ... (came) for a place to play in'. This was Noy's moment to shine. From high on the cliff, he held the iron pineapple above the head of the artist and dropped it 200 feet or so to the ground. The man and his easel crashed to the ground as his blood poured out, and his body jerked, struck by the weight of the pineapple.

Worse was to come. As Noy attended to the body he touched the man's hair. It came off (his beard, likewise). The man was announced as one Walter Grant, who had resided at No. 9 Victoria Road, Bude. The following day, the poor man was to have left for South America with a lady called Julia Dalby. The character, it seems, was the fictional Wesleyan, Bolsover Barbellion, denoted as a runaway rascal, spoiler of women, with false hair and beard. In this morality tale, all was well; the rascal was removed, and Noy felt directed by a higher hand to live a much happier life thereafter. Even in fiction, Methodism featured highly, generally perceived as a threat. If you can buy an old copy of the book, it is worth a read, along with other Cornish tales of the unexpected. Incidentally, another crime writer, Ernest Elmore (1901–57) from Kent used the pseudonym John Bude for his tales, many of which were set on the Cornish coast.

Now, on to fact. You've all heard of *Murder in the Cathedral* by T. S. Eliot, but who would have thought that Bude might have a story to rival it? How bloody a history the rural hamlet of Poundstock, 4 miles south of Bude, had in the fourteenth century when it was reckoned to be pretty much outside the rule of law. That actually might apply to much of old Cornwall. Poundstock, meaning 'settlement with an animal pound' was called Pondestock in the Domesday Book and is well worth a visit. It has a stunning Gildhouse, open on Wednesdays, which was built during the fifteenth and sixteenth centuries. The beautiful building was a large feasting house where 'church ales' were sold to raise money for the church or the parish. It has also been a poorhouse and a schoolroom, and has undergone a great deal of restoration using Lottery Heritage monies.

During the Hundred Years' War with France (1337–1453) there was something of a free for all taking place. Law enforcers were intermittently engaged in fighting the French, rather than maintaining law and order at home. So, places like the dramatic Widemouth Bay were prey to pirates, while inland villainy, at rural outposts like Poundstock, was also the name of the game. The jagged cliffs below the settlement were also the domain of pirates. Meanwhile, the Black Death was also wreaking havoc, so we can imagine a population in turmoil, and largely ungoverned/ungovernable, meaning the unscrupulous among them could reign supreme and unabated.

Murder Inside Poundstock Church

When is killing not murder? When it is on the battlefield. It makes a good deal of sense that those engaged in sinister criminal activity on the home front were also likely to be significantly violent and unscrupulous when fighting wars, so many brutal men were heroes on the battlefield and villains at home. Yet, their heroics often meant their villainies went unpunished.

The big Bude tale at the time of the Hundred Years' War was the murder of William Penfound, the assistant curate, in Poundstock. Not only was the poor man slain, but he was killed before the altar in St Winwaloe's Church, with a combination of swords and cudgels, a very brutal, bloody, and ugly end – blood apparently splashed on the vestments. Penfound and some of his kinsmen were mercilessly killed on the chancel steps, while sacred vessels were also desecrated – something of an irreligious free for all, and none too pleasant.

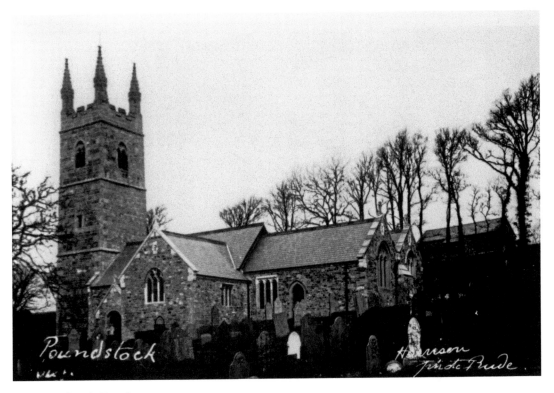

Poundstock Church.

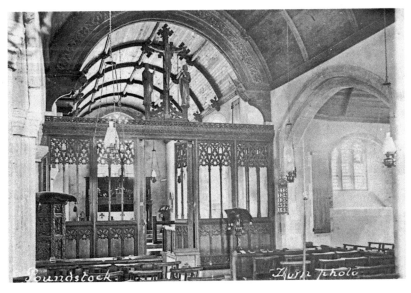

Inside Poundstock Church.

Poundstock Tithebarn, dating from the fourteenth century.

The event happened during mass on 27 December 1357, the Feast of St John the Evangelist. It is often said there is no smoke without fire, for it seems that William the curate was also a gang member who had quarreled with his colleagues, hence, the bloody revenge that was exacted. His restless ghost is said to wander, probably along with the others there which, according to the Cornwall Tour website include a vicar condemned to life imprisonment for complicity in murder, one hanged in Tudor times for leading a revolt against the Common Prayer Book, and one known as a local Lothario. On this occasion, the King, Edward III, commanded an investigation into events. Arrests followed and a trial undertaken at Lostwithiel Assizes on 26 Monday March 1358, three months after the offence was committed, which was remarkably speedy for those times.

The accused was one John Beville. Indeed, many members of the Beville family were implicated, including his mother, Isabella de Bosnegor, for either joining in the brutality or harbouring criminals as they fled. All pleaded not guilty and were acquitted on the capital charge, so escaped hanging. However, financially they paid the price, with lands and properties forfeited and heavy fines of up to £100 for the ringleaders. This was quite a sum then, and they did impertinently request installment payments. John Beville was later pardoned and continued to combine his Crown offices with his villainous career, including kidnapping wealthy merchants, ransoming them and plundering their goods. Curious what double lives people led; simultaneously, they were often both pillars of the community and ruffians.

As for poor old William Penfound, his ghost is said to haunt Poundstock Church, and who can blame him after such a grizzly end? People have reported entering the church to find the organ unexpectedly playing, so listen out for this when you visit. Some say it was not 100 per cent clear who the murderers were, though they were described (according to author Nicola Sly) by the Bishop of Exeter as 'satellites of Satan'. Certainly, when the sanctity of a church is called into question, it does seem rather shocking. Author Paul Broadhurst has written about Poundstock, which is described as 'picturesque' but also ghostly, and it is easy to see why it is so described. It always feels terribly atmospheric, with a shadow cast; whenever I visit it is almost always deserted, too. It is in something of a hollow, a dell, which always lends an eerie air. It is worth visiting for its church and the Grade I-listed Gildhouse.

Also in Poundstock is said to be the oldest, continually inhabited ancestral family home in England. Penfound Manor House, which was listed for sale in 2013 as a 'haunted property', was originally a Saxon dwelling, given by William the Conqueror to his half-brother. The Penfound family, who took their name from the manor, moved in during the twelfth century. During the Civil War, the Penfound family were Royalists, unlike their neighbours the Trebarfoots (these are good Old Cornish names, by the way: '... by Tre, Pol and Pen you will know the Cornishmen' who were Parliamentarians). It is hard for us to understand just how badly the Civil War divided communities but, put bluntly, the two sides detested each other. The Penfounds and the Trebarfoots had previously had trouble-free inter-family marriage, but this was no longer welcome in the new fraught political situation.

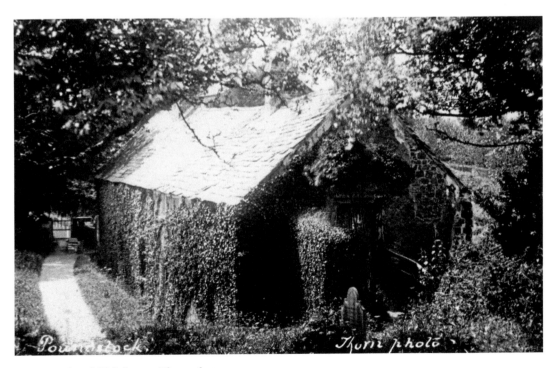

Poundstock Tithebarn, a Thorn photo.

Thorn of Bude, photographer.

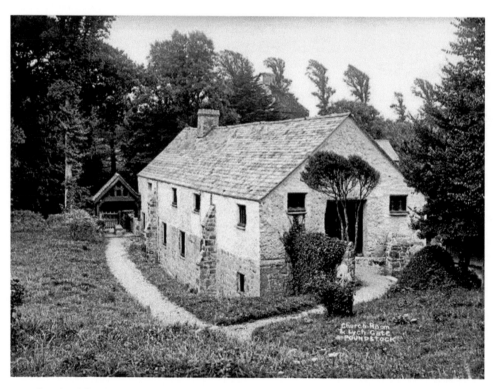

Poundstock Gildhouse and Lychgate, early 1900s.

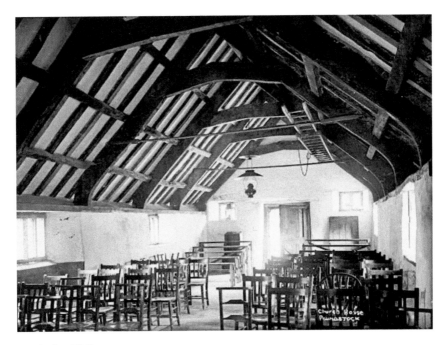

Inside the Gildhouse, 1911.

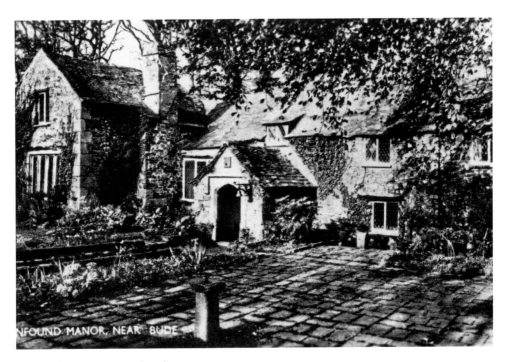

Penfound Manor at Poundstock.

In true Romeo and Juliet fashion, youngsters Kate Penfound and John Trebarfoot fell into forbidden love. Their only option was to elope, for a wedding was impossible and there was no way that they would just give up on the idea. As Kate climbed down a ladder to the courtyard where John was awaiting her, Kate's father discovered them and there followed a clash of swords. Poor John died during the fight and Kate is said to have been wounded by her own father's sword when she tried to intervene. She died shortly afterwards. Since then, the apparition of Kate has been seen in her bedroom and on the staircase. On 26 April, the anniversary of the fatal fight, all three have been seen in the courtyard replaying the action. The last of the Penfounds, incidentally, died in the poorhouse in 1847.

More recently, the Murderpedia website tells of a local rabbit trapper from Poundstock, William Maynard, who had over 1,000 traps in the area. He is said to have battered to death an eccentric recluse called Richard Roadley, aged eighty-four, who lived in a squalid cottage at Titson, near Marhamchurch, but was thought to be sitting on a tidy sum of money buried on his father's farm. Maynard attempted to blame another man called Harris, an alleged accomplice in the break-in, but he had an alibi. Thirty-six-year-old Maynard was tried for murder at Bodmin Assizes and hanged at Exeter Prison in 1928 by Thomas Pierrepoint and Thomas Philips.

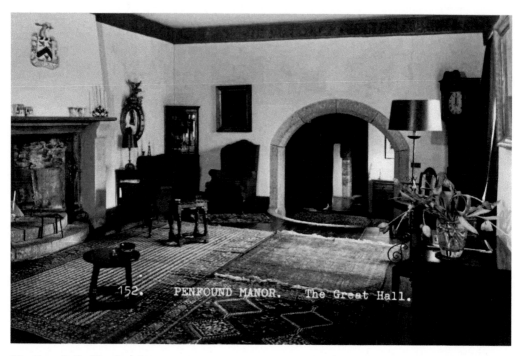

The Great Hall of Penfound Manor.

3. The Cruel and Curious Sea

It must be said I have borrowed this chapter heading from Cai Waggett, one of the leading lights of the festival Leopallooza which helped put Bude on the contemporary music map. Cai is also the brain behind the now-annual series of local art and photography showcase events held at Stowe Barton, near Coombe, called Cruel and Curious, which sums up the dark side of the sea. Stowe Barton was once a large farm en route to Duckpool. It is now a National Trust building, perched in the lee of a steep wooded valley not far from Kilkhampton, with views to GCHQ Bude, with its astonishing satellite dishes, based near to Houndapitt Farm where hounds were once kept for hunting. Duckpool is thought to have been named after the habit of ducking witches, but I suspect the decent numbers of ducks there are the real reason. While there are still witches in Bude, there is not a strong history dating back to the days of the ducking stool.

The sea is mightily powerful, as anyone who watches it during a storm will soon realize. The coast around Bude is known to be extremely difficult and rugged (with extraordinary views) so it is not too surprising that the area, with its so-called Bude Formation rocks and narrow inlets, has been known for many wrecks, especially in the days of sail. The best-known wreck is the *Bencoolen*, which featured previously in the tale of 'The Iron Pineapple'. Incidentally, among the few fossils found in the Bude Formation, is the extinct fish *Cornuboniscus budensis,* found only here (find out more at the Heritage Centre).

The Bencoolen

Bencoolen is a name etched into the annals of Bude history. We have Bencoolen Road, the Bencoolen Bridge, the Bencoolen Inn and even the shanty singers, the Bencoolen Wreckers. Information about the *Bencoolen* wreck, from which all this emanates, is in the Castle Heritage Centre, Bude, originally built by Sir Goldsworthy Gurney. It also contains the figurehead of the ship. Many parts of the barque are said to have been used in houses and other buildings around the town, so the town has been literally built, in part, from the *Bencoolen.*

While Bude offered some haven from the treacherous seas of the Atlantic, it also offered dangerous, jagged reefs, which have been the downfall of many a sailing ship, including the *Bencoolen* itself. Given its history, Bude may seem to be no haven, but compared to other parts of the coast towards Morwenstow, and Hartland, the small harbour at Bude offered some protection, plus a breakwater. That said, any haven was minimal, for even the original breakwater was destroyed by a terrible storm back in 1838.

The *Bencoolen* was a 1,415-ton cargo ship wrecked in 1862 during gale-force winds, a sight, watched by those on the shore and cliffs with mounting horror that we can only

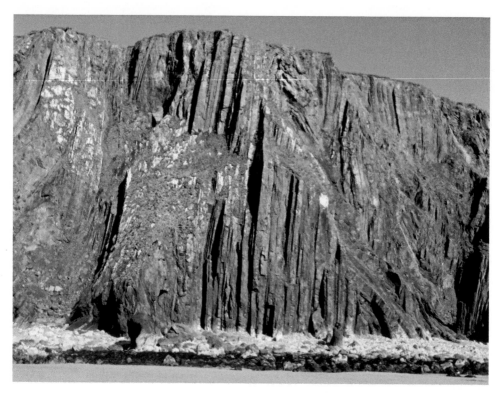

Stunning rocks near Bude.

Bude rocket apparatus for early rescues/life-saving.

begin to imagine. Only six sailors of the crew of thirty-three survived. The ship was wrecked close to Summerleaze Beach, at around 3 p.m. just yards from safety, but the sea was too rough to launch the lifeboat (two men almost drowned trying) so rescuers (the rocket brigade) relied on rocket apparatus, which broke in the huge waves rendering it useless. How lucky we are today to have the skill and dedication of the modern RNLI, plus Bude's own Surf Life Saving Club, started in 1953, which instigated surf life-saving in the UK.

Stephen Hawker, reverend at Morwenstow (1803–75) wrote at some length about the *Bencoolen*. He was agitated that the lifeboat refused to launch, attributing it to cowardice and Wesleyanism – a rather typical response. Throughout Cornwall, Wesleyanism and nonconformism had taken a hold (we see sizeable Wesleyan chapels in many seafaring areas of Cornwall, such as Mousehole) much to the chagrin of the established Church. It did not hold with the rules of the Church of England. It – and Wesley – was blamed for many things and Hawker was, at the time of his writing, an Anglican vicar.

The reality of the situation seems to be that there was no experienced crew available; indeed, the later investigation vindicated the lifeboat men for refusing to go out on a suicidal mission. 'A Croon on Hennacliff' was Hawker's response, which was highly critical of the actions surrounding the event. To be fair to Hawker, his response is understandable; he lived a life at times 'as lonely as Lundy'. He endeavoured to bury dead sailors, an unpleasant task, paying men for rescuing corpses and body parts from the sea.

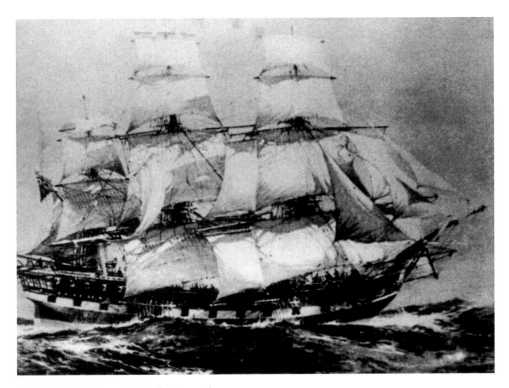

The *Northfleet*, sister ship to the *Bencoolen*.

Hawker's hut, Morwenstow.

The sight and stench of a body long dead, especially in the water, is not pleasant, so one can understand his agitation and irritation.

However, an alternative view was offered by a writer called Clifton, who described the distress of the villagers and a strong sense of mourning in Bude following the wrecking of the *Bencoolen*. He explained how, conversely, a winter wreck could be quite an exciting event when nothing much else was happening, but only when there was no loss of life. I like to go along with the idea that Bude was (and still is) more humanitarian than Hawker believed and that the long-term impact of the *Bencoolen* on the town amply demonstrates this.

Wreckers

Cai Waggett's annual exhibition pays testimony to the tempestuous waters around Bude, which has a reputation for its treacherous coast. Nautically, north Cornwall is a rocky lee shore, which means boats will drift into it by prevailing south-westerly winds. The Padstow to Hartland Point stretch – of around 40 miles – which incorporates Bude (despite the title Haven) was obviously a struggle for mariners. We've all seen Bude's rough seas, and its tides can also be a little awkward too, so one would expect to see a history of shipwrecks and sea struggle. Stamp and Bere mentioned (1980) that ships

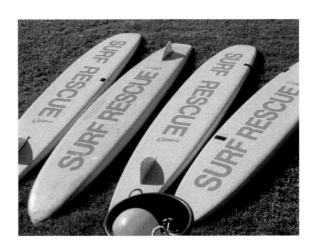

Bude Surf Rescue today.

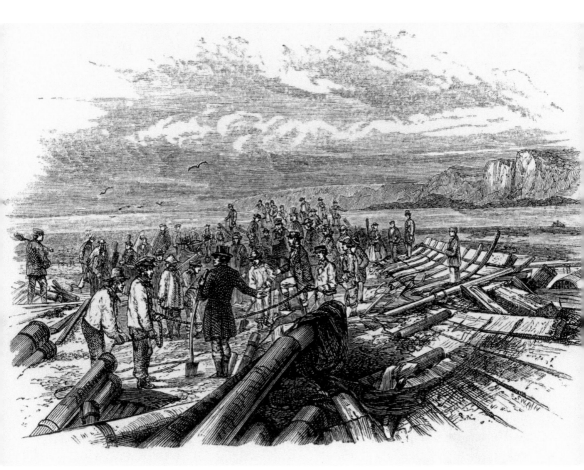

The *Bencoolen* wreck (image courtesy of Bob Willingham).

rarely came willingly into Bude. They were generally aided by 'hobblers' in an open rowing boat, who would pilot and help to moor the boats – quite a skilled task – requiring a good knowledge of the seas. Other vessels were, to their peril, blown in on prevailing winds and often suffered as a result when they hit the rocks.

Was it a wreckers' coast? Well, the answer is a resounding 'yes'. Records of wrecks near Bude go back many centuries. Stamp and Bere cite the case of the *Raphael* in 1467. This vessel was driven ashore near Duckpool, close to the large house at Stowe. Its valuable cargo fell into the hands of three local men, who then steadfastly refused to return it. More was removed by others, though it is open to question whether this boat was actually by then a wreck or not. There seemed to be something of a history of taking anything that turned up, regardless. Alcohol, for example, was often removed from boats whether they were wrecks or still sailing, the locals having a merry old time on gin and brandy. The area developed something of a bad reputation for mariners. Not only was the navigation difficult, but if you did hit the rocks you'd have the locals to deal with. The captain of the *Juanita*, for example, which was driven onto rocks at Duckpool not long after the *Bencoolen* was wrecked, apparently stood, sword in hand, ready to fight off the notorious wreckers from his vessel's sugar load. He was reassured by the coastguard and the crew was saved.

The three-mast *Bencoolen* had no connection with Bude but was en route from Liverpool to Bombay, with a cargo of iron telegraph poles on board. Heavy seas meant her demise, with the captain uselessly drunk to the point of oblivion in his cabin, and an under-led crew. Between 1862 and 1900, it is said that there were over eighty strandings in Bude Bay, with the loss of at least seventy lives, including boats like the *Capricorno*, a coal barque, wrecked in 1900 when parts of the sails were blown away in a gale and the ship became unmanageable. Eventually, the ship hit the Bude breakwater, and the sea broke over her, killing the chief mate and washing seven crew overboard, all of whom drowned. Again, the rocket apparatus struggled to rescue the ship. One man who survived the wreck, called Frontebella, jumped into the sea, according to the wreck report. He swam towards land and was pulled ashore by several men on the breakwater. He was taken to a house and given spirits and dry clothing. When asked if there had been any delay, he answered, 'No, they treated me like a son' and added that he was 'very kindly treated; the people on the shore could not have done more for me'. This is rather at odds with Hawker's general view of the locals. Last century was less dramatic on the wreck front, but even then, in February 1904, the steamer *Wild Pigeon* was carried away from a place of safety, moored on the canal, when waves broke the inner lock-gate.

The breakwater is not always protective. It is well worth a look to check out the views and Tommy's Pit open-air pool, but beware of slimy, slippy stones.

So who were these vicious characters known as wreckers and smugglers? Were they fact or fiction? Much as we love to embellish tales, there were, it seems, some true wreckers. Perhaps the most famous of these was Cruel Coppinger the Dane, said to operate in a schooner called *Black Prince*, from Marsland Mouth near Morwenstow. Part real, part legend, he was said to have arrived during a furious storm, which the locals turned out to watch. Coppinger was a giant among men, reminiscent of the old Viking invaders, said to be of Herculean height and build. He apparently married a local woman called Dinah Hamlyn, a girl he had 'carried off', so no one is sure if she had a choice, but one suspects not. There were tales of abduction and even a beheading at the hands of Coppinger and his gang. Hardly ideal husband material, it is said

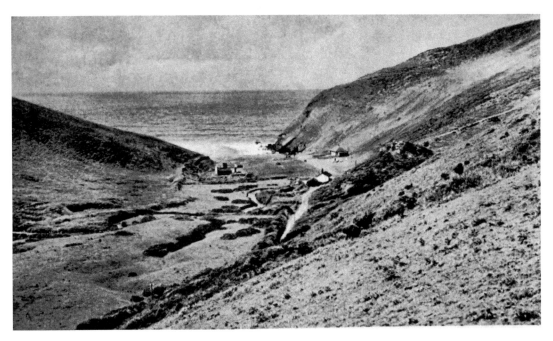

Morwenstow, Coombe Valley in the 1900s.

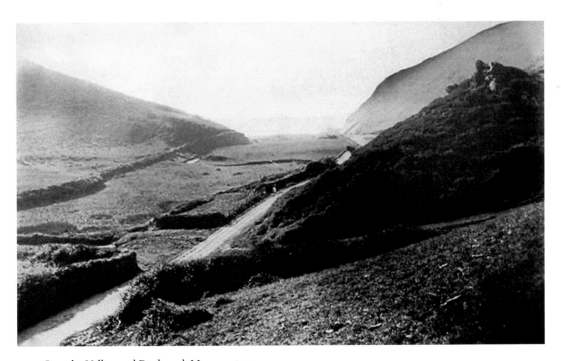

Coombe Valley and Duckpool, Morwenstow.

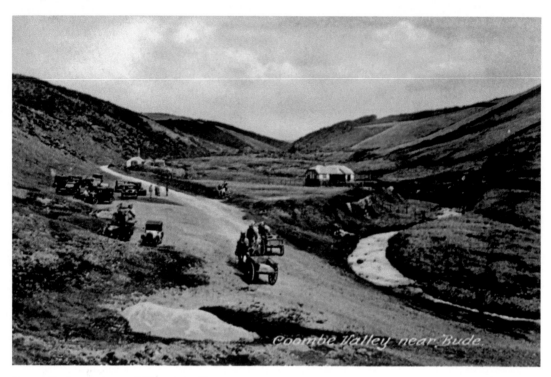

Cars at Duckpool, 1929, a Frith postcard image.

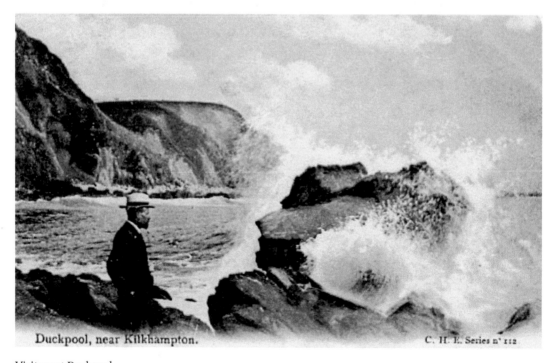

Visitors at Duckpool.

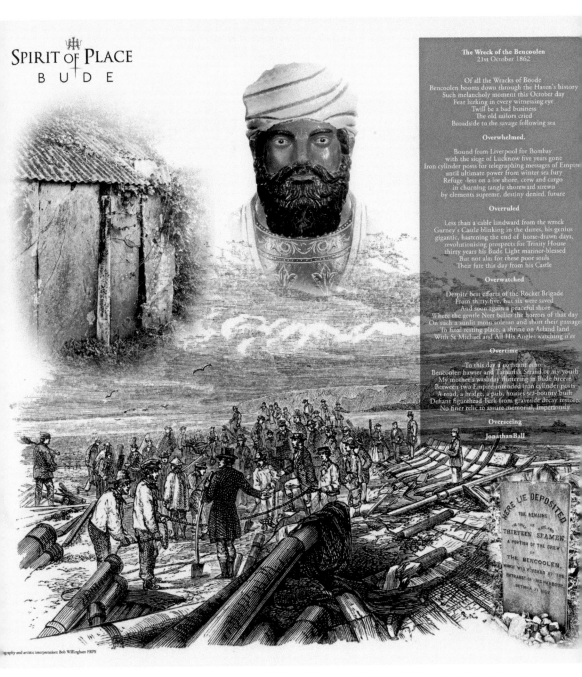

SPIRIT OF PLACE
B U D E

The Wreck of the Bencoolen
21st October 1862

Of all the Wrecks of Boode
Bencoolen booms down through the Haven's history
Such melancholy moment this October day
Fear lurking in every witnessing eye
Twill be a bad business
The old sailors cried
Broadside to the savage following sea

Overwhelmed.

Bound from Liverpool for Bombay
with the siege of Lucknow five years gone
Iron cylinder posts for telegraphing messages of Empire
until ultimate power from winter sea fury
Refuge -less on a lee shore, crew and cargo
in churning tangle shoreward strewn
by elements supreme, destiny denied, future

Overruled

Less than a cable landward from the wreck
Gurney's Castle blinking in the dunes, his genius
gigantic, hastening the end of horse-drawn days,
revolutionising prospects for Trinity House
thirty years his Bude Light mariner-blessed
But not alas for these poor souls
Their fate this day from his Castle

Overwatched

Despite best efforts of the Rocket Brigade
From thirty five, but six were saved
And soon again a peaceful shore
Where the gentle Neet belies the horrors of that day
On such a sunlit morn solemn and short their passage
To final resting place, a shrine on Acland land
With St Michael and All His Angles watching o'er

Overtime

To this day a constant echo
Bencoolen hawser and Tamarisk Strand of my youth
My mother's washday fluttering in Bude breeze
Between two Empire-intended iron cylinder posts
A road, a bridge, a pub, houses sea-bounty built
Defiant figurehead Turk from graveside decay restored
No finer relic to assure memorial, Imperiously

Overseeing

JonathanBall

HERE LIE DEPOSITED
THE REMAINS
OF
THIRTEEN SEAMEN
A PORTION OF THE CREW
OF
THE BENCOOLEN,
WHICH WAS WRECKED AT THE
ENTRANCE OF THIS HARBOUR,
OCTOBER 21 1862

ography and artistic interpretation: Bob Willingham FRPS

Bencoolen image used in the Spirit of Place Exhibition (courtesy Bob Willingham, Studio Southwest).

Tommy's Pit on the breakwater, courtesy of Laurence Walsh.

he extorted money from his mother-in-law by tying his wife to the bedstead and threatening to whip her with a sea-cat unless her mother paid up. His reward for his union was a deaf and dumb son who allegedly murdered another child at the age of six. No one seems sure what happened to him. Cruel was so named because of the choice he gave would-be recruits: join his crew or be tortured. He died in the sea. There was also a famous Widemouth Bay wrecker, Featherstone, whose spirit is said to be imprisoned beneath Black Rock, only to be released if he can weave a rope of sand – not much chance of that then.

There was one smuggling frigate said to have been based near Bude, sweetly called Two Cherubs. In charge was, in true pirate tradition, a one-legged villain called Simon Symonds. It is said that the King's man, John Silver (you couldn't make this up), caught Symonds red-handed one day and had his head cut off with a cutlass. The body was lashed to Silver's own white horse and driven into the sea, the head being buried in the wall at Grenville Cottage. Watch out for a crescent moon when, with three taps at the door, the headless body returns seeking its head. Of course, you will regularly see white horses in the sea.

In terms of smuggling, it wasn't ideal territory, unlike the sheltered creeks of south Cornwall, but it did occur, and there is said to be a smuggler's cave at Northcott Mouth. Heavy surf and exposed coast offered its own problems but the coast was less closely monitored by the customs officers than the secluded coves of the south; anyway, the customs men were often in cahoots with the smugglers and wreckers. Despite this, there were few run-ins between smugglers and customs men, although there is a lovely tale of a craft pursued for brandy and tobacco that contained only salt herrings. You can imagine the chase, and the look on the customs men's faces, when the master – allegedly – thanked the preventive men for helping his weary crew bring the vessel to port.

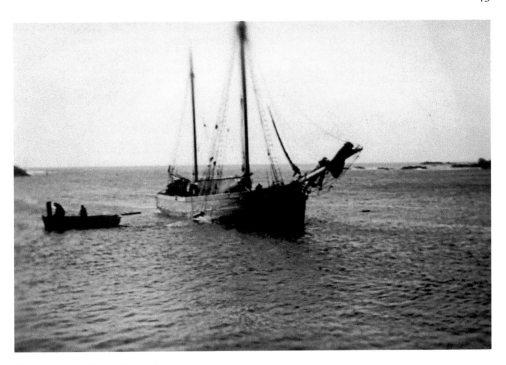

Ceres with hobblers taking a line.

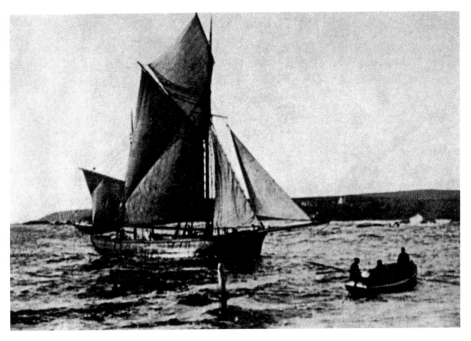

Ceres.

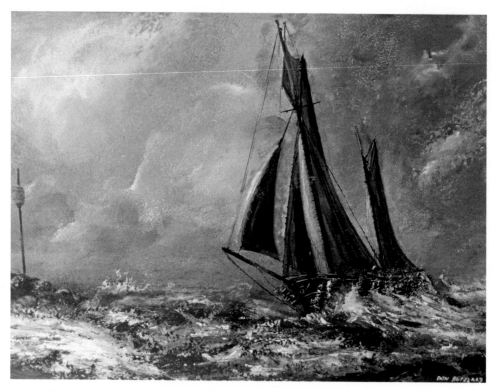

Rough seas at Bude, from a painting in the Castle Heritage Centre.

The Poundstock Pirateers

We tend to be a little romantic about pirates (the film franchise *Pirates of the Caribbean* didn't help, but the harsh reality is that not all pirates were Johnny Depp) with tales of swashbuckling fights against the Crown, but they were a vicious bunch who plundered anything for some gold doubloons. The men of Poundstock, Week and Treskinnick were said to be involved in the secret group of pirateers based around Cancleave Strand and they showed no mercy, as testified by the murder of William Penfound. The greater Bude area was ideal for piracy and merciless it was too: informants would be slaughtered and silenced forever. Little surprise then that somewhere near Poundstock, between Great Dizzard and Penhalt cliff, is said to be buried pirate treasure known as the Poundstock Hoard. According to Stamp and Bere, Bude Bay was covered by the Padstow customs men, so there were clashes between smugglers and excise men. A battle ensued in 1820 when excise men seized 400 tubs of foreign rum. They were shot at by smugglers who forced a violent retreat. Such events were however, few and far between. Wrecking was an eclectic career, involving everything from downright piracy to merely collecting flotsam and jetsam; it was also dangerous, as wreckers had to climb precipitous cliffs. John Bray of Poughill recorded thirty-seven wrecks in their heyday between 1759 and 1830. Obviously, they were not an everyday occurrence.

4. Mystical Bude

Bude attracts talented artists but also has its fair share of psychics, pagans, wiccans, and mystics, with regular Mind, Body and Soul fairs taking place in the town. Perhaps Bude's greatest claim to occult fame is its links with the artist of the famous classic Rider-Waite tarot deck, Pamela Colman-Smith, known by many as Pixie – a name allegedly given to her by the actress Ellen Terry due to her small size and appearance. Her family called her Pam. This tarot pack was the first to offer detailed drawings on the minor arcana (the fifty-six lesser) cards of the deck and is now world famous. Pamela was born in Pimlico on 16 February 1878, to an American, Charles Edward Smith (twenty-four) and a Jamaican, Corinne Colman (thirty-four). She lived her later years in Cornwall and died in Bude, though was not buried here. No one really seems to know where she was buried as she ended her days in an unmarked pauper's grave. Much of her later life remains shrouded in secrecy.

An excellent 2015 book, *Secrets of the Waite-Smith Tarot*, by Katz & Goodwin, tells how Pamela came to illustrate the tarot. Arthur Waite, esoteric poet and mystic, hired Pamela in 1909 to illustrate the tarot deck as she was 'a very skilful and original artist' who also had some knowledge of tarot values and was 'deeply versed in the subject'. It is suggested that Pamela was no intellectual, but was instead intuitive and immersive in her art.

According to a book by Melinda Boyd Parsons (2013) Smith (influenced by W. B. Yeats) joined the occult group, the Hermetic Order of the Golden Dawn in 1901, where she met Waite. She was also once exhibited by Alfred Stieglitz (a photographer and modern-art promoter) in 1907. She is said to have painted 'automatically' or 'without conscious control' making her a passive vessel, painting esoteric visions that came to her when she listened to music. Pamela would enter a trance-like state in the alchemy/astrology/theosophy tradition, when working with occult visions. Peculiar that such a talent (though she left a very small mark on modern-art history) ended up in sleepy Bude. Or is it? Well, not entirely. Susanna Dark, witch and psychic of Wise Old Crow at The Strand, says Bude is not like anywhere else. Due to ley lines, the whole of the southwest has a mystical feel, but many people say that Bude, the land and the sea, feels particularly that way. Maybe Pamela was in some way drawn here.

The reality seems to be that Pamela saw herself as an artist first and foremost; her knowledge of the tarot was perhaps not as great as Waite thought. Images suggest that she created a black-and-white pen-and-ink version of the cards first, the five-and-a-half-month project seemingly her one and only link to the tarot, very much a job in return for payment. Some say she borrowed ideas from the oldest existing tarot deck, the Sola Busca, which she might have researched in the British Library, but most people seek inspiration from somewhere. Very few reinvent the wheel.

Despite Waite describing her as 'an abnormally psychic artist', her cards were not well received at the time. She only developed popular appeal from the 1960s, long after

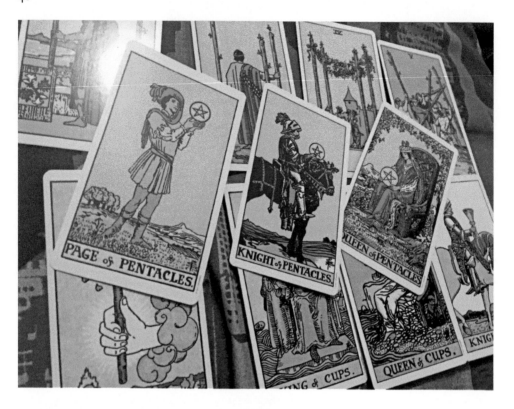

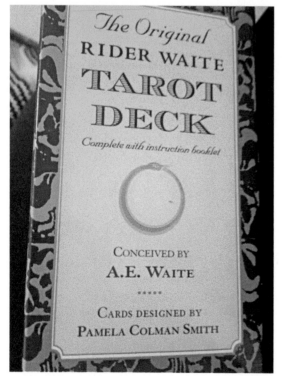

Above: Tarot cards from the Rider Waite deck.

Left: Rider Waite tarot deck.

her death. Waite reckons he worked hard to stop Pamela casually picking up 'floating images', which fed her the design of some of the major arcana cards. Back in Brooklyn in 1893, she was inspired by her teacher Arthur Wesley Dow to work by 'synaesthesia' (a union of the senses), being especially moved by music. It is widely believed that Pamela treated the tarot as a symbolist would, seeing the cards as without fixed meaning but subject to individual interpretation. Maybe one needs to be psychic or an artist (or both) to truly understand. It seems Pamela was not inspired by Bude for her tarot art (she did the work before moving here) but rather from a stay at Smallhythe Place, a rather pretty half-timbered house in Kent, where she visited her unconventional actress friend Ellen Terry. It is said that Terry, Henry Irving and Bram Stoker (author of Dracula) who were three senior members of the Lyceum Theatre, cared for Pamela when her mother died. She also knew the poet W. B. Yeats and his painter brother Jack, with whom she collaborated on a number of projects, so she certainly mixed with the great and good.

In 1911, Pixie surprisingly converted to Roman Catholicism, an action that seems to have no real explanation, and whereby her relationships with her former friends from the Golden Dawn seem to have deteriorated. W. B. Yeats' younger sister Susan (known as Lily) wrote in 1913,

> Pixie is as delightful as ever ... she is now an ardent and pious Roman Catholic, which has added to her happiness but taken from her friends. She now has the dullest of friends, selected entirely because they are R.C., converts most of them, half educated people ... she goes to confession every Saturday ...

In 1918, she moved to Cornwall. She had a sizeable inheritance from an uncle, which she used to buy a house and 2 acres at Parc Garland on The Lizard, where she created not an artist's studio as one might expect, but a chapel and a vacation home for priests, providing them with bedding and meals. She had a special chapel and allegedly wanted to have a priest available to perform daily mass. Little is known about her life after this time, but the venture was not a long-term success. Some commentators imply she was discriminated against because of her gender, her mixed ethnic origins, or possibly her sexuality, but all of this remains speculative. John Yeats did apparently call her (and her father) 'funny looking', but claimed her work was direct and very sincere. Reality is that, like many artists, work was scant and poorly paid, and she was not a great businesswoman so her ventures tended to fail. She is also described as eccentric, sensitive and changeable, qualities that may have had a big impact.

Interestingly, Bude has rather taken Pamela to its heart, so many people in the town would like her life to be marked with a plaque – or similar – because the links to the mystery woman do attract visitors to the town. Little is actually known about Pamela's time in Bude, so it was indeed an honour and a privilege to meet a gentleman called Tony, who was Miss Smith's (as he calls her, and as her father apparently also called her) errand boy in Bude, around 1943. It is Tony's first-hand testimony that throws more light on Pamela Colman-Smith's time in Bude than anything else I have encountered. Tony attended Bude Secondary School when his parents spotted an advertisement for an errand boy. As money was short, he joined Stanley Laurence Miller, 'high-class' fruiterer/

greengrocer situated next door to the electricity board. Quite coincidentally, Tony's aunt lived near Henley in Arden (Tony was born during his mother's visit to Ullenhall) and had previously met Pamela while at the Royal Shakespeare Memorial Theatre in Stratford, so perhaps a serendipitous link.

Tony recalled Pamela's upstairs flat in Bude, 2 Bencoolen House, at the back of the Bencoolen Inn, which was once a palatial gentleman's residence. When it was converted into flats, Pamela lived at No. 3. She shared with another lady, Mrs Nora Lake (Tony never met her, simply saying she 'hovered a lot') who was probably a very close friend, thought to have been an ex-housekeeper during the days of the priests' retreat. Pamela left all her belongings to Nora in her will, but they were auctioned off to pay off her debts, leaving Nora with nothing. Pamela, he says, was not exactly slim, and was grey around the temples, with her hair swept back into a bun, but by this time she was much older than in her earlier photographs. Interestingly, because the photos suggest otherwise, Tony said that Miss Smith was pale and in need of Cornish sun. She was pleasant and chatty, not pretty, and he would not have known her age. To a ten-year-old boy she was 'just old'.

Every week she telephoned the shop to give a very modest order, indicative of low income levels, and would also ask Tony to get a milk loaf from the bakery opposite. The chemist was close by, so Tony was also asked to get thermal wadding, like red flannel, used for her 'bad chests'. Her health in later life was not thought to be good. In the lobby of the flat, where he would deliver the goods, were many sketches of tarot cards which to Tony 'looked like gibberish, like the joker in a park of cards'. Tony, who has spent a lot of time in Germany, commented on the Germanic nature of Miss Smith's drawings, rather like those of the Brothers Grimm fairy tales.

They were weird drawings to his eye, and she never offered to read his cards, so was probably not a tarot reader. Sometimes, such as at Christmas or his birthday, Miss Smith would offer her errand boy the choice of half a crown or one of her paintings. He always took the money! He thinks she was short of money, but often wonders now whether she thought he was rejecting her work or she was simply trying to save cash. Sometimes, Tony would carry potatoes to the kitchen for her, but usually he just delivered to the lobby. He thinks Pamela at this time still had an outlet for her art products, which to his mind made her the purveyor of half crowns.

Tony said she was strongly Catholic, and in the flat 'Our Lady would be looking at you'. She even painted a crucifix on the front of her home, which she removed due to complaints in nonconformist Bude. She encouraged friends to join the Church, calling it 'such good fun' close to her death in 1951. She was very dedicated to Catholicism, enjoying, it is said, the rituals and devotions. She would have been in the minority here for Bude, conversely, was strongly Protestant. Tony explains that the Church (Anglican) was packed on a Sunday, but so was the Methodist Church. Tony attended both churches, hedging his bets. In the high Anglican one, he carried the incense boat. Tony was also a young Liberal (another West Country tradition until the 2015 General Election) and delivered their leaflets all his life.

Back to his encounter with Pamela, he says she had an easel in her flat with a painting on it. His employer, Mr Miller, was also an artist. The art world in Bude was then quite

small, unlike that of west Cornwall (Lamorna, Newlyn and St Ives). Tony was used to the artistic crowd floating in and out of the shop, but only once went upstairs himself where he found lots of easels and painting materials. There was a good view of the Bude Breakwater from up there. Miller's wife pretty much ran his business while he painted and enjoyed the company of groups of artists who gathered at his flat. No one knows why Pamela came to Bude, but Tony suggests that when the seminary closed, or she became less capable, that the Catholic Church maybe helped to relocate her. Being next door to St Peter's Church seemed to mean something to her. Moving to Cornwall took her a long way from London, so he wonders if something happened there. An ex-policeman who enjoys his hunches, Tony hazards a guess that it might well relate to a broken romance.

Tony went on to talk about his own upbringing in Bude. He was raised on Efford Farm, a paradise for a young boy. From there, he could hear the vicar, Revd Atkin at Ebbingford Manor, who would play the bagpipes with his son. He and his friends were apparently 'up and down the cliffs like monkeys'. They enjoyed recovering things from wrecks, salvaging materials brought in on the first tide (after this they would be ruined) and recalls recovering three enormous boxes of cigarettes which were hidden in barns by the shore. A Liberty Ship went down off Pentire Point with a mixed cargo. Tony says there were enough condoms to have provided contraception for the world! He would also find flags of Stars and Stripes, parts for vehicles, and his favourite: ration boxes containing tins of fruit, chopped ham and processed cheese, plus large tins of coffee. Candy and chewing gum were also welcome, along with tins of peanuts from the Americans. It was a big delight finding the deck hatch. A lot of the booty became incorporated into air-raid shelters in gardens. So, we had a driftwood-gathering boy, raised on loot from wrecks on the beaches, who also knew Pamela Colman-Smith.

Tony was a keen army cadet, for at this time Bude was jam-packed with troops (1940–44). It also had a 999-seat cinema where there was a queue every night. The train would take the cadets to Dorset via Taunton for training. Tony promised to return to see Miss Smith but never did, for his father found him a new job paying three times the money, two-thirds of which went to his mother as 'keep'. It was his father who told Tony that Miss Smith (he never heard her called by her earlier nickname of Pixie) had died. He recalled she had asked him about his ambitions, then promptly dropped the subject when the army was mentioned. He got the strong impression that she didn't approve.

Pamela (Pixie) Colman-Smith was not buried in Bude, says Tony, for there was no Catholic cemetery. More likely, she was buried in neighbouring Launceston. Yet her death certificate, recently uncovered at the Bencoolen Arms in Bude and shown to me by Susanna Dark, says she died of a myocardial degeneration (we now call this myocardiopathy/heart muscle weakness) at the Conservative club in Bude on 18 September 1951, and that she may have been cremated. There is no crematorium in Bude, so this may have happened in Bodmin. That said, she is listed as a burial in the parish of Budehaven on September 25, the ceremony presided over by a Roman Catholic priest. It is likely the case that Pamela would have been long forgotten if not for the Tarot. As one blogger wrote about Pamela Colman-Smith, she had 'a life lived genuinely'. Who wouldn't want that for their epitaph?

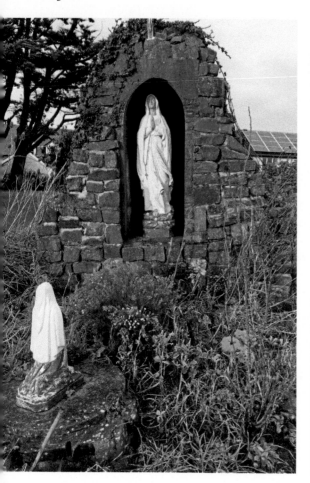

Above left: Bude's Catholic Church shrine at St Peter's (possibly St Bernadette of Lourdes).

Above right: Chapel at Ebbingford Manor.

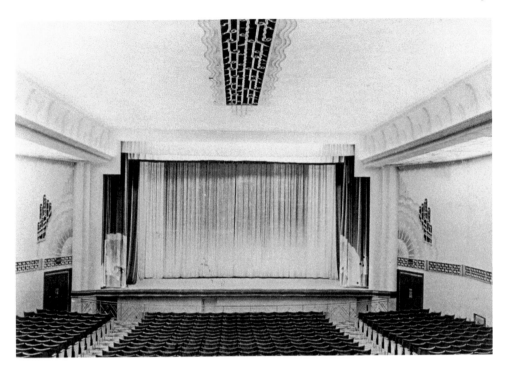

When Bude had a cinema in town.

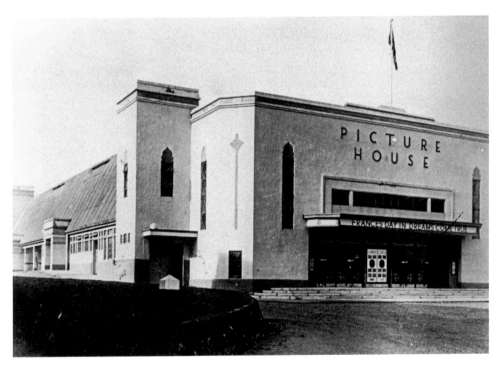

Exterior of the old cinema.

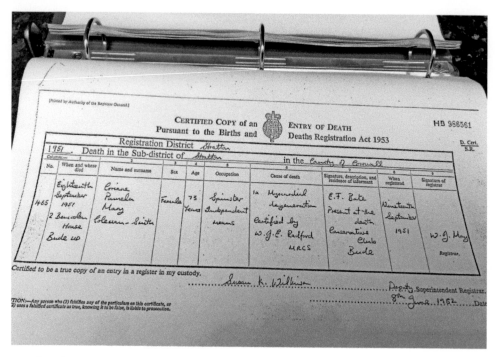

Pamela Colman-Smith's death certificate.

From this, Pamela Colman-Smith's remains appear in the burial list for Budehaven Parish, presumably in an unmarked grave.

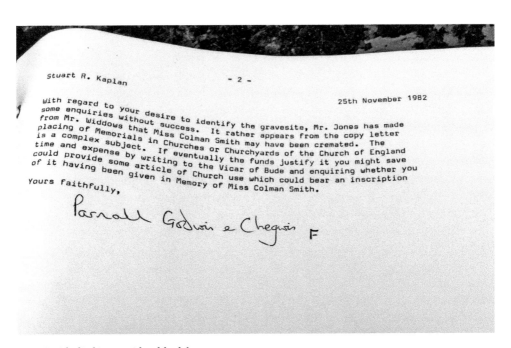

Miss Smith died in considerable debt.

5. Other Bude Characters

The *Titanic* and Bude's Archie Jewell

It is hard to imagine Bude having much to do with the ill-fated *Titanic*, which struck an iceberg on its maiden transatlantic voyage in 1912; however, it did. Described as one of the world's 'unluckiest sailors' (though it depends upon your perspective), Archibald 'Archie' Jewell was born on 4 December 1888 in Bude. Living on King Street, near the town centre, he was the youngest brother of siblings Clara, John Henry (Jan), Ernest W., Albert Richard, Elizabeth and Orlando (known as Land'O), the youngest surviving child of his parents, Elizabeth and John Jewell. King Street was (and largely still is) owned by the Blanchminster Trust charity. The street is said to have mainly been home to hobble men, wharf hands, and ketch captains, as well as lifeboat men.

On 9 April 1891, when he was two, poor Archie's mother died giving birth to a stillborn baby, a reminder of how very dangerous childbirth still was for women in the late 1890s. His father had just returned home after surviving the Great Blizzard while at sea on the 95-ton ketch, the *Ant*, led by a Capt. Hines. Conditions at sea were so dire during the blizzard that John Jewell was found wrapped in a mainsail with extremely swollen hands and legs; he suffered permanent frost-bite damage. The sailors, when found, could not stand and were administered brandy and medicine. A youngster, eleven-year-old John Stapleton, nephew of the Bude shipowner, died on the ship and was buried at sea. Times were extremely hard and sailing was a risky business; it still is.

The Great Blizzard of 1891 affected many parts of Great Britain but especially the South West, with strong gales and heavy snowfall, the likes of which were unheard of. Between 9 and 13 March, Devon and Cornwall were almost totally cut off. *The Times* on 11 March 1891, reported a deep depression. The Plymouth correspondent had telegraphed news of a 'terrific hurricane with an immense snowfall throughout the western counties...all traffic and business was stopped, and telegraphic and postal communication had completely broken down'. The suddenness of it was shocking, but what was suffered on land (snowbound trains, fallen trees, plummeting temperatures and violent gales) was little compared to out at sea.

Ships at sea struggled immensely, running aground on rocks but also struggling with poor visibility in the days before satellite communication. In 1891, much of Devon and Cornwall was cut off from Britain, a scenario only repeated during floods that swept away the railway line at Dawlish in February 2014 while also flooding many parts of Somerset. Then, Cornwall could still be reached by road, but it was a laborious process. The *Ant* on which John Jewell sailed was loaded with coal on a voyage from Saundersfoot in South Wales to Ipswich. The vessel was blown off course and was eventually spotted two weeks later in the Bay of Biscay. John, an active sailor until his death on 20 January 1936, sailed on many Bude boats including the *Ceres*. He was also a coast watcher during the war.

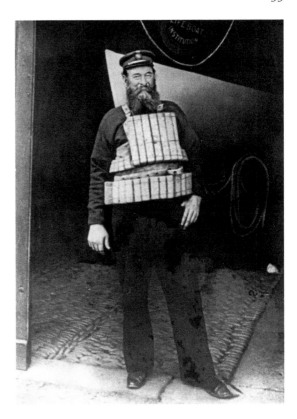

Lifeboat cox, Henry Stapleton.

Lansdown Road in March, 1881, after the Great Blizzard.

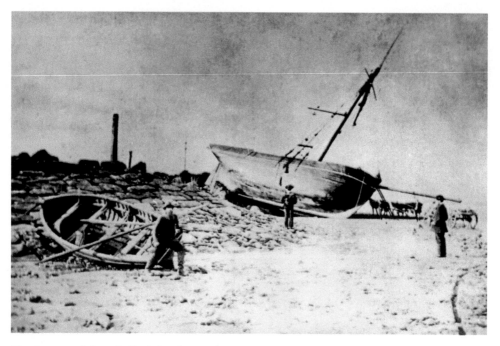

The *Ant,* stranded on the Bude breakwater – again!

In 1903, at the age of fifteen, Archie went to sea on tall ships, but later swapped them for steam, joining the White Star Line and serving on the *Oceanic* until transferring to *Titanic* as one of six lookout men. In the post of lookout he was paid a monthly wage of £5. Archie, twenty-three, a quiet man, non-drinker and non-smoker, was in the 'crow's nest' just before the ill-fated *Titanic* struck ice. A few years after the *Titanic* sank, on 24 August 1915, he married a local Bude woman, Bessie Heard, setting up home in No. 50 Bond Road, Bitterne Park, Southampton.

On 14 April 1912, Archie was on the 8 p.m. to 10 p.m. watch with George Symons of Weymouth, but was in his berth when the ship struck an iceberg, as his next watch was not until 2 a.m. to 4 a.m. He was roused from his sleep when the ship struck the berg by the news 'Titanic is shipping water fast'. It did not take long (by 12.45 a.m.) to see that the *Titanic* could not be saved. A ship that had taken three years to build at the Harland & Wolff shipyard in Belfast, the largest liner of its time, the 70,000 tons of steel, which myth reckoned was 'unsinkable', sank in less than three hours.

As quartermaster of the *Titanic*, Archie's duties included watch-keeping on the wheel. His emergency duty was to coxswain one of the lifeboats, launched earlier than most on the starboard side; this secured his survival. He, along with another sailor, was ordered to enter lifeboat number seven. His was the first boat to be lowered, holding twenty-eight people when its capacity was sixty-five, so it was an appalling error of judgement by those issuing orders. Those in the lifeboat, by this time cold and shocked, were later rescued by the *Carpathia* and taken to New York, where Archie telegrammed to advise he was safe. He returned on the *Lapland*, where he wrote his sister Ann a graphic account of the Titanic's sinking:

We was in the boat for six hours before the steam boat came to us. When it came daylight there was iceburghs all around us and about 20 miles stretch of small ice.

I shall never forget the sight of the lovely big ship going down and the alful crys of the people in the water and you could hear them dying out one by one, it was enough to make anyone jump over board and be out of the way.

Had there been boats enough nearly everyone would have been saved. If the watertight doors had worked she would not have went down.

Archie was the first person to be questioned at the subsequent inquiry on 3 May 1912, held at the Scottish Drill Hall, Buckingham Gate, London, where he was examined by the Solicitor General. He became one of the few *Titanic* witnesses to be thanked for his testimony by Lord Mersey, President of the Inquiry, who said, 'Thank you, Jewell; and if you will allow me to say so, I think you have given your evidence very well indeed ...' As his watch had finished two hours before the iceberg was struck, there was no culpability. In all, Archie answered 331 questions, mostly about his role in manning the lifeboat.

In his testimony, Archie said he heard the crash first, which woke him up. He then ran on deck to see what it was and saw some ice on the fore–well deck on the starboard side. He went down and put on some clothes but assumed there had been no harm until, shortly after, the boatswain called for all hands on deck. When lifeboat number seven was lowered (this took around thirty minutes) to the rail, the order for women and children to go in the boat was given, along with instructions not to allow men on board. He explained they had problems getting people in the boat as they were afraid, but also did not think anything was wrong. He said there was no excitement, it was all very quiet. When the boat (mainly women, only one child) was lowered it was without light, but he could see the ship slowly settling. The whole process of leaving the ship to the ship going down he thought took around one and a half hours. When the stern sank, the boat went down pretty fast. As the stern went up in the air, Archie heard two or three explosions close together. At daybreak, Archie said he saw icebergs all around them. When collected, he and the passengers had been on the boat in icy conditions for around seven hours without food and water.

After *Titanic*, Archie went back to sea. At the outbreak of the First World War he served on liners used as hospital or troop ships. In 1916, his ship *Britannic*, sister ship to *Titanic*, was sunk by enemy fire in the Kea Channel of the Mediterranean. He suffered a bad cut to the head. 'I ran up the boat deck and then someone tied my eye up so I looked like old Nelson. I was nearly done for – there was one poor fellow drowning and he caught hold of me but I had to shake him off so the poor fellow went under.'

Not sure I'd have opted for another crack at drowning, but Archie did (maybe he had little choice) and was this time less lucky. On crossing the Channel as an able seaman, to bring back some war wounded, the hospital ship SS *Donegal* was hit in a surprise attack by a German submarine on 17 April, 19 miles south of the Dean Light Vessel in the English Channel, and sank. The *Donegal* was launched in 1904 as a passenger steamship, built by J. Caird and Co, but later requisitioned and converted into a hospital ship. Yes, this time poor Archie went too; he was only twenty-eight. Archie gets a mention on the Shalder Hill

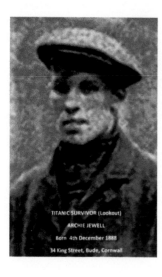

TITANIC SURVIVOR (Lookout)
ARCHIE JEWELL
Born 4th December 1888
34 King Street, Bude, Cornwall

Archie Jewell, *Titanic* survivor.

War Memorial, Bude, but also on Tower Hill Memorial, London, which commemorates Merchant Navy men with no known grave. His son, Raymond Hope Jewell, was born in 1916 but died in 1930 (aged fourteen) in Exeter. He was buried in the churchyard of Burlsecombe, Devon. Bessie was also buried there in 1966, with Archie remembered on the stone. Archie's letters outlining his role in the *Titanic* events were sold in 2008, auctioned for £17,500.

Another link to *Titanic*, the Cornish Bard, Peter Truscott of Bude, died in 2007. Truscott's on Lansdown Street is linked, for Peter was born in a room above the shop in 1923. His grandfather was N. J. Hawking, shipping agent, who sold tickets, including five for the *Titanic* sold to Bude people wishing to emigrate to Canada – one survived and four drowned. All in, Bude had a few links to *Titanic*, with Archie being the most important one of all.

Thomasine Bonaventura

This is a proper fairy tale which reads rather like *Cinderella* or maybe *Dick Whittington*.

Week St Mary near Bude is 530 feet above sea level, described by Sabine Baring-Gould as a 'treeless wind-swept situation'. In the village are the remains of dark-haired Thomasine, a shepherd girl. She was born around 1450, daughter of a sheep farmer whose herd grazed the common land. One day, a London wool merchant, Richard Bunsby, came upon her as she was spinning while tending her father's sheep. He asked some questions about his way, finding her to be both intelligent and beautiful, so he invited her to be a servant for his wife. Seeking parental permission, she parted from her parents; their advice to her was to be 'obedient and modest' for wool merchants were reputed to be of good repute and substance, and acted in a very seemly manner.

Unveiling the Bude War Memorial in 1922.

Thomasine was introduced to the house and did her work dutifully and cheerfully, but the mercer's wife promptly and fortuitously died. Maybe she did not like this young interloper on the scene. The widower – of course – offered his hand and heart to the lovely Thomasine. He too died three years later. As a young, rich and attractive widow she drew many suitors. She then remarried a merchant adventurer called John Gull. He allowed his wife (because they did in those days) to make donations for poor relief back in Week St Mary.

After five years she was widowed again. Fresh suitors buzzed around her like proverbial flies to a treacle barrel. In 1497, she married Sir John Percival who, a year later, became Lord Mayor of London. To commemorate this, she, obviously a practical woman, constructed a good road from Week to the coast. She survived her third husband and, presumably by then, had endured enough of life in London and husbands. She returned as Lady Bountiful to her native village, founded a charity and a free school (in the days when they had a different meaning), the remains of which survive. The buildings lie 100 yards to the east of the church.

A different version of this story is in the *Cambridge Companion to Medieval Women's Writing* by Barbara Hanawalt. Here, it is suggested that the beautifully named Thomasine was born into Cornish gentry in the 1450s, and that her brother, a priest, had London connections. She entered a merchant tailor's household as an upper-class servant and married her widowed master. When he died in 1467, he left her half his property and some cash to take over his business, but she married another tailor. He died within a year, again leaving her half of his estate. She then married a third time, to John Percyvale, Mayor of London, who died in 1503. She took over the business and trained apprentices. We do not hear whether she had children, but wealthy widows seemed a popular marriage option. The second version of the story sounds more historically likely, but the rags to riches version is much more romantically enchanting.

Alfred, Lord Tennyson

Locals know that the Poet Laureate, Lord Tennyson, stayed at The Falcon Hotel in Bude in 1848, after he felt a 'craving' to visit Bude. A lover of Cornwall and the legend of King Arthur, in his *Idylls of the King* (1859–85) he allegedly said, 'I hear there are larger waves there than on any part of the British coast, and must go thither and be alone with God.' He could not have guessed that Bude would become a surfing Mecca, and indeed that the surf rescue service would start here with the Bude Surf Life Saving Club (SLSC). For those who don't know, the SLSC organises an annual Christmas Day 'no wetsuits allowed' dip at Crooklets, perhaps now the largest in the country, which is well worth enjoying as a participant or observer.

Of course, this was well after Tennyson's time. Arriving at Bude in the evening, he is said to have cried 'Where is the sea? Show me the sea!' After seeing the sea, he went stumbling in the dark, fell down (some say over a low wall) and hurt his leg. Did he simply fall? Had he partaken of fine ale? Who knows? Well, maybe we do. Robert Cooper, in his *Literary Guide and Companion to Southern England* wrote in 1998 that 'It is hard

What Bude is perhaps best known for: surfing.

to imagine anyone so dignified as Tennyson – and so aware of that dignity – taking a pratfall.' But take one he did at Bude, and of monumental proportions.

It seems Tennyson shot through the back door opened by a 'stupid' servant girl, and crashed 6 feet to the gravel beach below. It took six weeks for him to mend (quite a gash, then) and move on, so he was stuck in Bude, like it or not. I rather think he did like it … and hopefully assumed some blame for his own exuberance rather than the alleged stupidity of the girl.

He was seen by Dr King of Stratton (quite an honour really, as most people were lucky to see a doctor at all) and convalesced at the Falcon and at No. 12 The Crescent. For his full praise of Bude, check out *Idylls of the King*, a cycle of twelve narrative poems retelling the tale of King Arthur in blank verse. Ignoring the earlier work of Thomas Mallory, Tennyson decided to create Arthur's origins not as human but as a child of the sea:

> But after tempest, when the long wave broke
> All down the thundering shores of Bude and Bos,

John Batchelor in his book *Tennyson: To Strive, to Seek, to Find* (2014) writes that Tennyson made friends with the Revd Stephen Hawker, suggesting they were rather alike. Both were big men (Tennyson was 6feet 1inch), enjoyed wild landscapes and the company of 'simple men'. Both were also rather dandyish (Tennyson wore a dashing Spanish cloak and

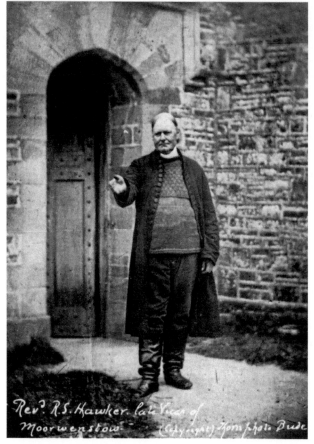

Above: The Falcon Hotel, where Tennyson once stayed.

Left: Revd Hawker of Morwenstow Church.

hat). When Tennyson met the reverend, Hawker's mind had not yet become distorted by opium, but interestingly John Betjeman wrote that 'Hawker was the finer poet', certainly when underpinning his work with Christianity. Tennyson's brother was an opium addict, and Platizky suggests his own artistic temperament and pipe smoking left him open to speculation too; hence his opposition to it in *The Lotus Eaters*, 1832. We must remember however, that in Tennyson's time opium, such as the painkiller laudanum, was popular and used rather like aspirin is today.

Reverend Stephen Hawker

I'm not alone in finding the maverick, and somewhat eccentric, Revd Stephen Hawker fascinating and someone I'd love to have met. What's interesting? Well, there are many jolly tales about him and and his slightly 'off the wall' ways of doing things. For example, how many Church of England vicars living in a highly Protestant area would convert to Catholicism on their deathbeds? That in itself is unusual and worthy of investigation.

Much of my information about the eccentric Morwenstow vicar comes from a book by C. E. Byles, circa 1905. Hawker had his own peculiarities, which living out in Morwenstow at that time might well have accentuated as the social and geographical isolation would have been immense, but was also probably partly attributed to his character and his eccentric habits. He was always clean-shaven, would not wear anything black, preferring a brown cassock, and is said to have once been mistaken for a woman by a child from Bude. Visiting Hawker's patch at Morwenstow, the crows cawed and screeched a warning of my approach from their nests in the higher reaches of the churchyard trees (why do graveyards always have crows?). It is easy to see why life at the little Cornish village of Morwenstow might have attracted the unusual Anglican vicar to its isolated position, which would not have been to everyone's tastes.

It would have been a lonely life, for Morwenstow was merely (and still pretty much is) a collection of farms, quite widely spread, with a road that often flooded. It would have been muddy for much of the year and treacherous in winter, so was, and still is, geographically remote, if not quite godforsaken.

Most local lore focuses on Hawker the opium-smoking eccentric, but his achievements had lasting national impact. A knowledgeable farmer, Stephen realised the importance of the harvest for survival. He therefore started the custom of harvest festivals in 1843, when he invited parishioners to a service of thanksgiving in the church at Morwenstow, decorating it with home-grown produce and singing hymns like 'We Plough the Fields and Scatter'. This developed into a tradition that swept through the country. As a boy, he had improved his grandfather's hymn 'Lord Dismiss Us With Thy Blessing' and had a definite way with words, especially poetry and verse. By the age of ten, Plymouth-born Hawker was reading and writing poetry and was already seemingly something of a practical joker, running away from school many times until he was sent to Liskeard Grammar School in Cornwall, where apparently he was happy, spending his holidays with his father at Stratton or with his grandfather and aunt in Plymouth. He went off to read law when school was over, but quickly changed to train for the clergy.

At the age of nineteen, on 6 November 1823, he married a forty-one-year-old Charlotte I'ans, whose income helped finance his studies; they honeymooned at Tintagel. Did he marry her for money? Probably not, for it seems he was a kind and attentive husband. Maybe he loved her, he needed a mother figure or his choices were limited and he just wanted to marry someone. It is all conjecture. Seemingly, they were very happy together despite the age difference. Byles mentions that when Col Wrey I'ans (Tans) died in 1816, he'd left four middle-aged, though charming and accomplished, daughters, and Hawker's wife was one of them. They lived partly at Whitstone and partly at Efford Manor in Bude, where Hawker spent a good deal of his time with them, presumably in search of a wife. Tradition says that before he was accepted by one sister, he was refused by another. A poem in *Tendrils* called 'A Remembrance' is thought to confirm this. Hawker himself was a prolific writer, though scandalously honest or mischievous in his material.

He remarried after his wife Charlotte's death when he was sixty, this time to a twenty-year-old Polish girl named Pauline Kuczynski, who bore him three daughters: Morwenna, Rosalind and Juliot. Age was no barrier to him, in either direction. In later life however, even these blessings could not stop the bouts of melancholy and depression that Hawker suffered.

In an example of the reverend's unusual ways, Hawker was said to have been met one day by a labourer in Tamerton who told him a sack of potatoes had been stolen from his garden. In church, Hawker mentioned this and that the thief was sitting there with a feather on his head. The thief surreptitiously touched his head – what a great way to catch a thief. Hawker's mermaid tale is also well known in Bude (Biide). A trickster, he was said to have dressed up in seaweed and not much else, sat on a rock in the moonlight combing his hair and singing 'An' ther' 'e set an' zinged every night, till a varmer tiikt a gun an' tried to shut un'. The poor simple folk of Bude were completely taken in. This is the tale taken from Sabine Baring-Gould's *The Vicar of Morwenstow*, 1876, which many people think was full of inaccuracies, but it's a pretty tale anyway:

One absurd hoax that he played on the superstitious people of Bude ... At full moon in the July of 1825 or 1826, he swam or rowed out to a rock at 'some little distance from the shore, plaited seaweed into a wig, which he threw over his head, so that it hung in lank streamers halfway down his back, enveloped his legs in an oilskin wrap, and, otherwise naked, sat on the rock, flashing the moonbeams about from a hand-mirror, and sang and screamed till attention was arrested. Some people passing along the cliff heard and saw him, and ran into Bude, saying that a mermaid with a fish's tail was sitting on a rock, combing her hair, and singing. A number of people ran out on the rocks and along the beach, and listened awe-struck to the singing and disconsolate wailing of the mermaid. Presently she dived off the rock, and disappeared.

Next night crowds of people assembled to look out for the mermaid; and in due time she re-appeared, and sent the moon flashing in their faces from her glass. Telescopes were brought to bear on her; but she sang on unmoved, braiding her tresses, and uttering remarkable sounds, unlike the singing of mortal throats which have been practised in do-re-mi. This went on for several nights; the crowd growing greater, people

Charlotte Hawker.

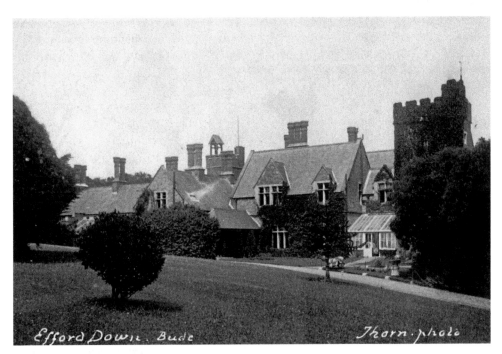

Efford Down House, early 1900s.

arriving from Stratton, Kilkhampton, and all the villages round, till Robert Hawker got very hoarse with his nightly singing, and rather tired of sitting so long in the cold. He therefore wound up the performance one night with an unmistakable "God save the King" then plunged into the waves, and the mermaid never again revisited the "sounding shores of Bude.'

Cornish Anthem

A man of many talents, he is perhaps best known for writing: *The Song of the Western Men,* praised by Dickens, Sir Walter Scott and Macaulay, with its chorus of

> *And shall they scorn Tre, Pol and Pen*
> *And Shall Trelawny die?*
> *Here's twenty thousand Cornish men*
> *Shall know the reason*
> *Why*

now considered to be the Cornish anthem and known far and wide outside of Cornwall. Pretty amazing, given he was born across the Tamar, in Devon. Hawker seemingly published this anonymously but was later 'outed' by no less than Charles Dickens.

On the plus side, Parson Hawker, as he was known to his parishioners, was considered deeply compassionate, a trait which he perhaps inherited from his deeply religious and generous doctor father, who would typically give the blankets from his own bed to the poor, sometimes leaving his own family without any. Hawker became someone who paid local wreckers, men known for their own poverty and brutality, to bring in dead mariners so they could have a Christian burial. This was no mean feat as the mariners did not emerge from the sea wholesome; as they smashed against the rocks they would be carved into 'gobbets' of humanity, forming gruesome sights. Hawker thus, allegedly, had to fortify his rescuers (gathered from the parish) with strong alcohol, to perform their grisly task. Even wreckers, it seems, were human.

Hawker was involved in the wreck of the *Bencoolen*, which is mentioned in the chapter on the cruel and curious sea. This ship was wrecked following a 'hurricane' which lasted a week. Her hull was seen wallowing off Bude. At 3 p.m. she struck the sand close to the Breakwater, 300 yards from the rocks. Apparatus was brought down to the shore, a rocket fired and a rope carried to the ship. The mate sprang to catch it, missed, and fell into the sea. Another rope was needed but none was there. A raft was constructed and launched. There was a call for the lifeboat, with a shout for men, but none were willing, which did not impress Hawker. A few men got on board but refused to be put off to sea. The people of Bude lined the cliffs and shore. Six sailors were washed ashore still alive (later to die presumably, judging by the numbers of dead) along with four corpses, and the rest were carried off to sea, dead.

The upper half of the *Bencoolen* washed away and was stranded opposite the cottage, while the lower half of the hull lay there ripe for the hordes of wreckers/salvors who

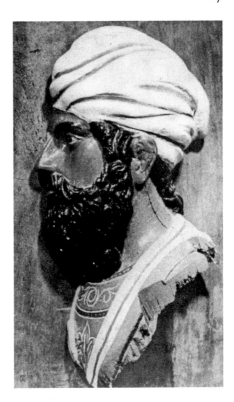

Bencoolen figurehead.

brought their carts and horses. When the masts went over, the captain, said to have been married a fortnight before, allegedly rushed down into his cabin, drank a bottle of brandy and was seen no more. How we know this is anyone's guess. As mentioned, Hawker felt the whole event brought shame on the 'dastards of Bude', but most see Hawker's damning indictment of the lifeboat men of Bude as misguided. Maybe Hawker was right, or he may have just been taking out his ire on the men because they were dissenters. So, let's take another approach …

An eyewitness account of the *Bencoolen* is mentioned in C. F. Crofton's *Bencoolen to Capricornio*, a book about wrecks in Bude, 1862–1900. He says that when the *Bencoolen* sank, there were really no skilled hands to man the lifeboat. Of nineteen coasting vessels, only two were in the harbour. Most men were unaccustomed to such tremendous seas. He wrote, 'I do not think that this question is put by any sensible man who has seen the awful possibilities of a Bude sea'. Indeed, the Bude men who saved lives from wrecks did it 'quietly, unobtrusively, in the interests of humanity'.

A white replica masthead/figurehead used as a grave-marker in the churchyard, is in place at the St Morwenna and St John the Baptist churchyard in Morwenstow, representing forty doomed sailors from the boat *Caledonia*, with its cargo of wheat travelling from Odessa to Gloucester, and Alonzo. Incidentally, a tortoise apparently survived the 200-ton *Caledonia* wreckage, which was pushed onto rocks in a gale. Sadly, most of its mariners were then killed by the mast which fell on them. Sailors would normally tend to be buried at sea or, if still alive, left on the beach, often knocked out first by wreckers taking

Bencoolen figurehead, courtesy of Bob Willingham, Studio Southwest.

whatever booty they could find. So, it was a dodgy area, with treacherous seas and rocks and even more treacherous locals. By comparison, Stephen Hawker was indeed a 'good egg', and demonstrated a compassion beyond his times. He apparently loved animals too, including Robin, his domesticated stag.

His poetry should not be under-estimated. Check out his poem 'The Butterfly'. Wikipedia, not a reliable source it must be said, reckons the man was unusual for a vicar, in loving bright colours, with his only black garb his socks; his mourners apparently all wore purple at his funeral in Plymouth. He was also reputedly known for talking to animals, having a black pet pig, called Gyp, and excommunicating his cat (one of nine) for catching mice on a Sunday. Do Anglicans ex-communicate? I don't know. Maybe this was a sign of the religious conversion to Catholicism to come. Rather more sensibly, he built a driftwood hut on the cliffs so he could look out at the Atlantic and write poems and hymns, or as some might say, to search for shipwrecks. Some light is shed on his excommunication activities by his being baptized – rather shockingly for an Anglican vicar – as a Roman Catholic when on his deathbed. Presumably, the leanings were there.

Some say Hawker, a tall, fair, blue-eyed, ruddy-complexioned man and last-minute converted Catholic, deliberately practised deception and hypocrisy during his life. But why would he? It does not seem to fit his character. A bitter newspaper controversy raged on about his conversion for weeks after his death. It is said that Hawker did not ask for a priest but his wife summoned one, believing it to be his desire. She felt he would never have sent for one himself because he realised the controversy this would cause for the

wife he left behind, which raises a few questions. Hawker retained a deep affection for the Church of England and believed in the sacraments. He did struggle however, with the rationalism of his age. He did his duty and it is impossible to fix in time when his convictions may have changed. A few weeks prior to his death, he conversed with a John Shelly from Plymouth. Hawker had argued very strongly against the infallibility of the Pope, but retained an interest in and affection for the Catholic church. Even Shelly was thus not prepared for the conversion.

We must bear in mind that Hawker changed his mind often. He was old and diseased and had taken a good deal of opium. His wife also joined the Church of Rome after her husband's death, which reinforces the idea that it was maybe her preference more than his. Even today, the vast majority of religious affiliation in Poland is Catholic. Hawker, very weak from heart disease, died in Plymouth, having felt for some weeks that his life was ending. His nephew reckoned he was not in his right mind at the last fortnight (he possibly suffered a blood clot in his left arm) and was confined to bed. Canon Mansfield received him into the Catholic Church saying he was welcoming, peaceful and thankful. His wife wrote, 'All was done in accordance with my own expressed wishes, based upon indirect suggestions of my Husband's'. It may have been an error of judgement on her part or it may have been his heartfelt desire. Cardinal Newman said 'we are no judges of the thoughts and sentiments which come over a dying man', believing his conversion to be a very last-minute switch.

Sir Goldsworthy Gurney

A Valentine's baby, born 14 February 1793, Gurney has often been called 'a man of genius'. He started adult life as a country surgeon, but is better known for his inventions. His invention of greatest relevance to Bude was the Bude Light, at first intended for lighthouses and patented in 1838. It didn't work for that. He had a house at Reeds in Poughill at the Castle, Bude. Knighted in 1863, he was sadly paralysed and looked after by his eldest daughter, Anna. He had two wives during his life, and died in 1875, buried at Launcells just under the south wall of the nave.

I'm maybe one of the few who finds Bude Castle a strange-looking building, though it is iconically Bude. Gurney's design drew inspiration from the Romantic movement of the second half of the eighteenth century into the nineteenth. The Romantics enjoyed castellation, turrets and towers. The building was designed by someone aware of the fashions of the day but without a true eye, as so many were. It is built on 2 acres of sand dune overlooking Summerleaze which belonged to Sir Thomas Acland, built as a way of proving that a sizeable building could be constructed on sand if done properly, the moral of the story being to never tell an inventor that something is impossible. The notion of things collapsing when built on shifting sands is also a philosophical one. The original house was smaller than the current version. In a way, it was a form of laboratory for Gurney, who trialed his inventions there, most notably the Bude Light. He was believed to have lit the entire building with one Bude Light, directed into each room with lenses and mirrors.

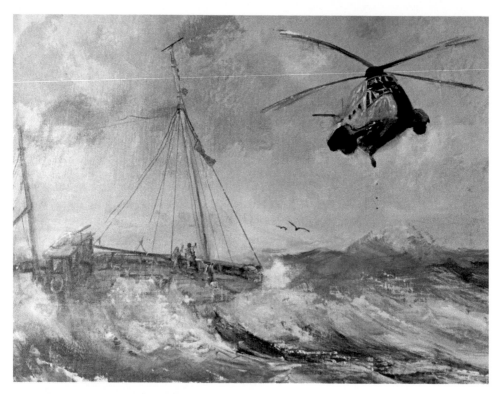

Painting in Bude Castle – air-sea rescue.

The Bude Light, possibly, situated in Trafalgar Square (courtesy of John Dunbar Walsh).

The Bude Light sculpture was created to celebrate this. Built in 2000, it celebrated both the millennium and the invention of the Bude Light. Using coloured concrete with fibre optic lighting, it was created by Boscastle painter and sculptor, Carole Vincent, with Anthony Fanshawe. The concrete is supposed to represent the colours of sand, sea and sky. Over 9 metres high, it weighs around 6 tonnes. 130 holes were drilled into the lowest section of the cone for the fibre-optic lights to depict the night sky. The cone is surrounded by the Zodiac circle. Red bricks in the paving are said to mark the points of the compass and the tip of the cone's shadow at local apparent noon from 22 March and each month to 22 September.

There is a picture of Anna Jane Gurney in the Castle. Anna, hair Florence Nightingale-style, was the elder Gurney daughter, born at Wadebridge in 1815. Following the death of her mother in 1837, Anna became Gurney's constant and devoted companion, helping with experiments and paperwork. Then he did the unthinkable and remarried, this time a young lady called Jane Betty in 1854. She was a twenty-four-year-old farmer's daughter; he was then sixty-one. It is easy to imagine the animosity of the daughter displaced by the younger stepmother. Anna, thirty-nine, disliked her and, not too surprisingly, the marriage failed. While no divorce occurred, his wife was written out of Gurney's will. Anna resumed her role in 1860, caring for him at Reeds after he was paralysed by a stroke, and ensuring he received credit for his inventions.

Gurney's inventions might not grab some of us today, but they were important and the engineers in my family find them fascinating. The oxy-hydrogen blowpipe (credited to Robert Hare) underpinned limelight. Gurney also used the steam-jet to clean sewers. This linked his medical and mechanical knowledge, serving to help eradicate cholera. The year 1858 was the year of the Great Stink in London, when temperatures grew so high that raw sewage on the banks of the Thames started hissing and bubbling. Gurney proposed solutions to address the smells, but his attempts were allegedly sabotaged for political reasons, with Joseph Bazalgette allegedly enjoying the benefit.

Bude lights, replacing 280 candles with but three of them, were fitted in the House of Commons. He also worked on extinguishing mine fires and eradicating explosions in mines, after 101 men and boys were killed in 1835 in a mine explosion at Wallsend Colliery, Newcastle-upon-Tyne. In 1849, he was asked to extinguish a coal mine fire near Manchester, and in 1850 extinguished a fire burning in a mine at South Sauchie Colliery, Scotland, which had raged for thirty years, covering an area of 26 acres. It was allegedly started by people illegally distilling whiskey in the mine. Gurney's knowledge extinguished the fire, saving an estimated £200,000 of property, which would equate to £17.5 million today. The Gurney Stove provided extensive heating in cathedrals, such as Ely, Durham and Peterborough. His inventions were all very useful. The inscription on Gurney's gravestone reads, 'To his inventive genius the world is indebted for the high speed of the locomotive, without which railways could not have succeeded and would never have been made.'

Anna Jane added her own tribute: 'He originated the Electric Telegraph, High Speed Locomotion and Flashing Light Signalling. He invented the Steam Jet and the Oxy-Hydrogen Blowpipe.' His obituary in *The Engineer*, dated 12 March 1875, reads as follows:

With regret, we record the death of Sir Goldsworthy Gurney, a man of considerable eminence as an inventor. Be was the son of Mr. John Gurney, of Trevorgus, in Cornwall, and was born in 1793. he was educated for the medical profession. He gave lectures on chemical science at the Surrey Institution in London. But his career was invested with peculiar interest for engineers, by his connection with steam locomotion on common roads. In 1822, Gurney stated in a public lecture on chemical science that elementary power was capable of being applied to propel carriages along common roads with great political advantage, and that the floating knowledge of the day placed the subject within our reach.

He soon afterwards constructed a little locomotive, which worked successfully with ammoniacal gas, and the results of his experiments were so satisfactory that be subsequently built a steam road carriage. In 1826 be ran this carriage several trips in the neighbourhood of London, ascending Highgate Hill without difficulty.

In 1827, he effected further improvements and turned out a steam carriage, with which be made a trip from London to Bath, and on one occasion be ran from Melksham to Cranford Bridge, a distance of 84 miles, in ten hours...

In 183l, a carriage built by Gurney for Sir Charles Dance, ran regularly between Gloucester and Cheltenham, for four months, four times a day, during which time it carried about 3000 passengers and ran 3,564 miles. Generally, the distance, nine miles, would run in 55 minutes. Prohibitory turnpike rates ultimately turned this carriage off the road. Gurney invented the oxy-hydrogen, or Bude Light, so called, from his Cornish residence, in 1825. Ho carried out several improvements in connection with his system of lighting, among which was an arrangement of reflectors for dispersing the light in gradually dispersing rays from the lantern, and a ventilating chandelier, which was also so contrived as to evaporate small quantities of water for the purpose of keeping the atmosphere of the room in a salutory condition.

The Bude light was tried for the first time in street illumination on the loth January, 1842, at the crossing in Pall Mall at the bottom of Waterloo Place. It is said to have illuminated the whole of the open space in which stands the Athenaeum Club very powerfully, and to have caused the gas lamps to look as dim as at that time the oil lamps at the end of Gower Street did to the gas lamps when established.

Gurney likewise devised the well-known stove which goes by his name, and a method of mine ventilation, which consisted in taking high pressure steam down the shaft and then allowing it to escape in an upward direction through a number of jets. Sir Goldsworthy Gurney died last week at his residence, in Cornwall. For the last eleven years be suffered from paralysis. In his youth, he was associated with Davies, Giddy and Trevithick, and no doubt imbibed from them much of his love of mechanical science. Sir Goldsworthy Gurney was a magistrate for the counties of Devon and Cornwall.

Other Famous Bude Characters

For such a small town, Bude has a surprising number of links with well-known people from many walks of life, especially creative ones. Here's but a few:

Jean Rhys (1890–1979) is best known for her novel, *The Wide Sargasso Sea*, written as a prequel to Charlotte Bronte's *Jane Eyre*. It was the story of Jane Eyre's 'madwoman in the attic', that of the white Creole heiress, Antoinette Cosway, who married Rochester. Rhys sadly struggled with alcoholism and marital problems, spending much of her life in England in penury. It was however in Bude where she started writing the *Wide Sargasso Sea* in the late 1950s, eventually published in 1966. Another writer was George Mills, who, given his middle name of Acland, probably had family links. He was born in Bude in 1896, becoming a preparatory schoolmaster and writing boys' adventure stories. Another author named Mills was Arthur F. H. Mills who was born in Stratton in 1887. His genre was war and adventure.

John Bolitho (a proper Cornish name) was Grand Bard of the Cornish Gorseth who became a member of the Black and White Minstrels. According to the Bude-born architect and Eden Project co-founder Jonathan Ball, Bolitho started his life in King Street, Bude, born 10 December 1930, the son of a butcher. The war years were spent in Marhamchurch where he was a Telegram Boy. Telegrams were old-style 'email' which arrived in a leather pouch. Bolitho delivered news, good and bad, by bicycle. At fifteen, he went off to sea as a submariner, cycling between Plymouth and Bude on every leave.

Somewhat propitiously, on one occasion, Bolitho missed his ship, a Norwegian whaling boat, and ended up in London. There, in an unusual twist, his voice led him to Billy Cotton's Band Show and the George Mitchell Black and White Minstrel Show, where he worked for twelve years. Yet, despite the glitz, he loved Bude and returned to a cottage in nearby Canworthy Water and temporary employment at Davidstow Creamery. His wife Heather met him on Boxing Day 1957, on a train. She was said to have been captivated by his singing from the buffet car. He later became one of the Bude Lifeboat Singers. Bolitho also became a town councillor and a north Cornwall district councillor. As a candidate for Mebyon Kernow, he was the first person to speak Cornish at Strasbourg in the European Parliament. In Bude he owned, with Heather, the Troubadour Restaurant in Belle Vue and then the shoe shop in Queen Street. He died aged seventy-four in 2005.

Back to the literary ... Valda Trevlyn Grieve was born in Bude in July 1906. The 'Tre' in her name marks her out as a Cornishwoman. Beth Junor has written an introduction to a book of fascinating letters between Valda and her husband, for Valda met Christopher Murray Grieve (known as Hugh MacDiarmid, the modernist poet) in London in the late 1920s, becoming his feisty second wife. According to the 25 May 1989 obituary in the *Glasgow Herald* captioned 'Runaway fell in love with poet in pub', Valda was a lifelong Cornish nationalist, and poet. She shared a cottage in Lanarkshire with her husband for twenty-eight years. As her father died when she was a baby, she was raised in an all-woman household.

At nineteen, bucking the trend of convention for pre-war women, she left home by going as far as her life savings would take her, hoping for London but settling for Bristol in the first instance. She wrote, 'I had only been in a train or cafe once before and I was frightened out of my life'. She met Grieve in a literary pub in High Holborn, not believing him to be a poet, but nonetheless finding him very attractive.

During their early marriage, they were impoverished on Shetland, so it helps that Valda was a strong character. Junor writes (2007): 'The postal system was much more

impressive than today. There were two deliveries daily, and a letter posted in Bude, Cornwall, in the morning, could reach Shetland in less time and more reliably than it now takes for a first class letter to reach Edinburgh from London'. She and her husband were both Anglophobic, saying, 'They contaminate everything, don't they? What a dreadful nation! Scotland and Cornwall are joined to England, that's half the problem. You need a strip of water between you.' Her own poetry was notably about her husband and is said to have sustained him throughout the rest of his life.

In 1934, Valda was entreating Hugh to move from Shetland to Bude, or rather Widemouth Bay. She'd found a cottage a quarter of a mile from the beach, a decent size, with a flower garden. She sounds very keen in her letter, especially as their child could be left with her mother, Florence Rowlands, in Bude. She wrote, 'This calls for love, I think – so here goes.'

Sidney Horley wrote *A Man of Affairs* and was said to have lived in Bude around 1950–51, according to a letter found from one Michael Smith of the Crescent Post Office to local historian Bryan Dudley Stamp. A crime/thriller writer, he went to the post office regularly from his living space at Pen Rock on Breakwater Road, and is remembered as a fairly flamboyant character wearing flashy ties and smart suits. His book took him to the High Court in London to defend a libel action brought by a Bude man. Two of the chapters in the book describe an incident relating to some missing bowling shoes, for which he was sued. It appears that other characters were recognised in the book, including Revd Atkin, who moved to Fairfield Road in Bude. Horley lost the libel action but was insured against it, so merely lost revenue from his book, which was banned. He is said to have, ironically, spent some of the money on the pavilion at the bowling club, but eventually left Bude due to bad feeling.

The Bude Canal and Harbour Society says that on Bude Canal Day, July 2009, held in conjunction with Gurney Day, the event was officially opened by one Count Nikoli Tolstoy – not THE Tolstoy I hasten to add. The count spent time at the castle when it was a private residence before the Second World War. This is not the only Tolstoy link with Bude. The Heritage Centre in The Castle tells us that Dame Edith Nicholson inherited the lease to The Castle in 1930 too, and was visited by a number of White Russian emigres, including members of the Tolstoy family and Sergei Obolensky, cousin of Alexandre Obolensky, who played rugby for England.

The American Geographical Society in their *Geographical Review* (April 1969, pp. 246–249) published an obituary of the eminent geographer, Laurence Dudley Stamp, 1898–1966, who lived in Bude. He died of heart failure, aged sixty-eight, while attending a conference in Mexico City; he had just managed to complete a quest to visit every country in the world. Born in London, Laurence had poor health and missed a great deal of schooling, but he was accepted as a student at King's College, London, at the age of fifteen. In 1917, he sat his BSc finals in geology and passed with First Class Honours. He later taught in Rangoon and London, retiring in 1958. Before that he served in the British Army in France and Belgium between 1917–19.

1930 was a critical year for Laurence Stamp when he inaugurated the Land Utilisation Survey of Britain (the modern Domesday Book) mapping every acre in the country, creating 6-inches to 1-mile land-use maps of incredible accuracy. By the beginning of the Second World War, Stamp came to the attention of the government which was pretty keen

on maximising land use. His home in Bude was the lovely Ebbingford Manor. Locally active, Stamp was President of Bude Town Band and a habitual local committee-man. He also wrote thirty books and 100 articles – decent ones at that. The man was prolific, vital in energy and stature. In his obituary he is described thus: 'His manner was mild, his grades generous and his sympathies clearly with the underdog.' It is said he was never too busy to nip back to Bude and would prepare for a talk in church just as much as he would for a Royal Commission. 'He took part in everything in which he thought he could contribute something of use.'

What many people may not know is that Professor Laurence Dudley Stamp was once a castaway on Roy Plomley's Desert Island Discs on 6 May 1963. His favourite track was the Hallelujah Chorus from Handel's Messiah, his favourite book was *Everyman's Encyclopaedia* and his luxury was wine. Given his name, it is fitting that he was a keen philatelist.

Stamp's son Bryan continued to live at Ebbingford (also known as Efford) Manor, parts of which date from 1193. It is mentioned by Carew in his *History of Cornwall*. Apparently one of the pivotal scenes in Daphne du Maurier's civil war novel, *The King's General*, takes place a few miles north of Ebbingford, when heroine Honor Harris is, in May 1628, staying at Stowe, home of the Grenvilles. Sir Laurence is said to have acquired Ebbingford in 1953 after a splendid dinner with the then vicar Canon Walter Prest, when they decided to switch their Bude houses.

A letter in the collection of papers owned by the late Bryan Dudley Stamp also tells of a time before the turn of the century when two young sisters came to Bude. In the face of warnings about dangerous undertow, they went into the sea from Summerleaze. A huge wave threw one sister to the beach and another out to sea. None of the men who tried to save her could get through the surf and all agreed that the only man in Bude strong enough to do it was working on a building around a mile inland. After a delay, he arrived on horseback.

The rescuer got through the surf and eventually saw a dark head in the hollow further out. As he swam on, he lost sight of her. Then incredibly, in the turbulent water he saw bubbles rising. He dived, caught her by her hair and saved her life. She had lost consciousness, which kept her alive; had she struggled, she would have probably drowned. Not everyone was so lucky. Another story was of a young serviceman who brought his younger brother with him to Widemouth. They undressed and left their clothes under a notice warning against bathing at low tide. They sadly didn't return to claim their clothes.

Over the years, the young builder-rescuer earned a number of medals or certificates from the Royal Humane Society for saving lives at sea. Becoming a master-builder, he knew there were currents swirling around Bude Bay and because bodies had been washed up further north, he surmised that a current flowed through from Bude itself. Confident of his swimming strength, he went into the sea and allowed the current to take him where it flowed. He was carried close to Northcott Mouth, which confirmed his hypothesis.

When the breakwater was built to stop the flooding of the marshes and to protect those living in The Crescent who, from time to time, had to be rescued from their bedrooms into boats, the builder declared the straight-sided breakwater would have no chance against

Northcott Mouth, 1900s.

Atlantic gales. He was right. The current structure however, with long sloping sides of stone, broke up the direct force of the ocean and still works today.

The builder became an expert restorer of churches. Later, he became a justice of the peace, and once was described as the 'uncrowned king of Bude'. He died in 1927, aged eighty, having had a daily cold bath from which, in winter, the bathroom windows steamed up from his body heat. He left many sons. One of these, Arthur, an architect, lived in Breakwater Road and died of appendicitis. The youngest daughter, Kathleen Janet, gave her life to looking after her parents. She christened the house in Falcon Terrace 'Squint Cottage', as she claimed there wasn't a right-angle in it. The young man's name was Ross Heard.

Hailing from Bude, Stanley Lucas was a male supercentenarian born on 15 January 1890. He was born in Morwenstow and his family moved to Marhamchurch in 1908. In 1948, he moved to Poughill where he continued to live after his wife Ivy died in 1963. Stanley, although called up, escaped serving in the First and Second World Wars due to a heart condition (maybe this saved his life). The hard-working man was a non-smoker and teetotaller, who helped instead on the family farm and set up his own dairy farm in 1940. In his spare time, he was a keen bowler, playing until he was 100. He was also a Bude town councillor (1959–70). After the death of war veteran Harry Patch (111) in 2009, he became the oldest living European male. On 21 June, Lucas died at the age of 110 years and 157 days, so never quite made the top 100 oldest men.

Bude doesn't immediately come to mind when you think of squash, but retired squash champion, Jonah Barrington, was born here (well, Morwenstow) in April, 1941. In 1982, he wrote his book *Murder in the Squash Court*, about his greatest matches. Barrington won six British open titles between 1967 and 1973. According to an article in *The Independent*,

George Henry Johnson, Bude's first official lifeguard.

Barrington's chief skills were stamina 'boxing with racquets', 'relentlessly keeping the ball in play, grinding away at his opponents, waiting for their physical and mental defences to break and then going in for the kill'. He was known for his endurance. More recently, DJ Simon Mayo talked to the students of Budehaven School about his fictional character, Itch. Itch's house is in Ocean View Road where Simon spent his childhood holidays; it is surprising just how many people do know and love Bude.

Historical Characters

Curiously, given Bude's geographical isolation, some historical characters had links with the great and good; others were just well known in the locality.

Known as the 'Falstaff of the west' the bluff giant Anthony Payne was born in the Manor House, Stratton, son of a tenant farmer, and lived at The Tree Inn. It seems his schoolmates were accustomed to working out their arithmetic lessons in chalk on his back, and sometimes to delineate a map of the world 'so that he might return home, like Atlas, carrying the world on his shoulders'. We might now think this was a form of bullying, but he too had his moments. He would enjoy tucking two boys under his arms to a height overhanging the sea and dangle them there. He called this 'showing them the world'. Sounds like Payne got his own back.

Aged twenty-one he was taken to Stowe, measuring 7feet 2inches in his shoes. He later grew 2 more inches. He was not tall and lanky but stout, well proportioned, and incredibly strong.

Tree Inn, Stratton.

A tale goes that one Christmas Eve, as the fire fizzled out, a boy with an ass was sent to the wood for faggots. Payne went to hurry him back, caught up to the ass and its load, flung them over his shoulder and returned. He also carried a bacon hog from Kilkhampton to Stowe, having being dared that he could not do it. More nobly, Payne was in the Battle of Stamford Hill in 1643. Mounted on his (presumably large) cob, Sampson, the Royalist, is said to have terrorised the enemy with his bulk. After his death in Stratton, neither door nor stairs would 'afford egress for the large-coffined corpse'. The joists had to be sawn through and the floor lowered with a rope and pulley to allow him to be buried under the south wall of Stratton Church.

In Blanchminster Castle at Stratton (now merely ruins at Binhamy) there are reports of a ghost haunting by Sir Ranulph Blanchminster, who died in 1338. When he returned from the Crusades, it seems his wife had thought him dead and so remarried. He spent the rest of his days living rough on the land around the castle, and his ghost apparently appeared in the former moat. Binhamy was first recorded in 1335, spelled as Biename, a corruption of *bien-amie* (well-loved). The castle was still standing in 1438, but by the early 1600s it was recorded as 'ruined'. Revd Stephen Hawker wrote a ballad about Blanchminster in 1867 called Sir Ralph de Blanchminster of Bien Amie. Hawker's ballad suggests Sir Ranulph reaped five wounds in battle.

Living at the great house at Stowe (then written as Stow), Sir Richard Grenville was son of Roger Grenville, captain of the *Mary Rose* when it sank in the Solent in 1545. Richard

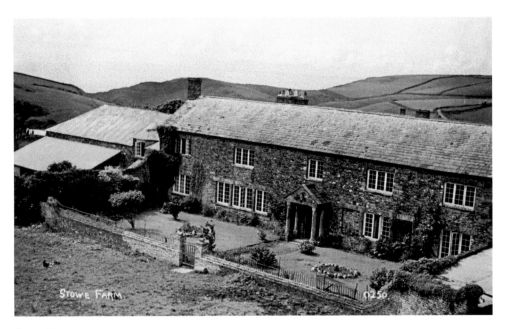

Stowe Farm.

Above left: Civil War costume, Castle Heritage Centre.

Above right: Civil War uniform, Castle Heritage Centre.

became a naval captain, cousin of Sir Walter Raleigh and friend of Sir Francis Drake. Bevil Grenville (1596–1643) was grandson of Richard, representing Cornwall in Parliament and raising a regiment of Cornish footmen to form an effective Royalist unit. When the Earl of Stamford led a Parliamentary invasion of Cornwall in 1643, Grenville, knowledgeable about local terrain, was able to assist Sir Ralph Hopton, the Royalist commander, to mount a surprise dawn attack on Stamford, driving the Parliamentarians out of Cornwall. Grenville himself was wounded by a halberd blow to the head, and died from his wound the following day. He left behind seven sons and five daughters but the Battle of Stratton, 1643, became a Royalist victory, which has been commemorated annually in Stratton.

6. Wartime Bude and GCHQ

Bude has quite a rich history of wartime involvement. Certainly, young men were drafted from the town for both wars, and horses from Bude were also used during the First World War. Sadly, most of them did not return from the carnage. People were also evacuated to Bude, such as the boys from Clifton College.

The Old Cornwall Society mentions a lesser known but sinister aspect of World War I in Bude Bay, the U boats. They were there to torpedo shipping bringing vital supplies home and would attack as they entered home ports. Fishing fleets were vulnerable targets. Of course, the sea could be difficult enough without U-boat attacks. The proximity of the attacks to land was partly related to morale. Let people see the ships go down and they would feel demoralised. Usually, the method used was to take off the crew, taking prisoners or setting them adrift in dinghies, then bombing the ships. An airship base to locate submarines was thus set up at Langford in Marhamchurch. Airships from Langford would fly over the sea to guard convoys. Not all came back.

SS *Belem*

During the latter part of the First World War, the small Portuguese steam ship, SS *Belem*, ran aground in thick fog at Menachurch Point, near Northcott Mouth. This was on 20th-21st November, 1917. The ship was carrying a cargo of iron ore bound for Cardiff. The 33-strong crew was rescued but the ship broke up. Much of the vessel was salvaged. At the Point, you can still see, at low tide, the remains of SS *Belem*. The propeller shaft sits at the end of Bude breakwater, supporting Barrel Rock.

An archivist called Audrey Aylmer wrote on the Old Cornwall Society website of an account by a man called Arthur Madge, who was nine years old at the time of the wreck and six years old when war broke out. He described five loud bangs around midnight on 20 November. In the morning, the housemaster of his school (St Petroc's, then in Killerton Road, Bude) walked the boys across the cliffs to see the spectacle of the life-saving gang in action using breeches buoy apparatus. Arthur was sent to Bude to board, so grew up by the seaside and knew the town well. He was born on a farm on the border of the Tamar, near Launceston, which relied on horses (there were no cars).

The Portuguese crew were all rescued and treated kindly, including a cabin boy. Arthur found the whole heroics very exciting, as many young lads would, and it was an amazing educational opportunity too. Mr Madge also mentioned often seeing, on his walk across the high cliffs to Widemouth Bay, German U-boats charging their batteries. By the time the authorities were alerted, the boats had re-submerged. Diesel generators meant they had to be brought to the surface to be recharged.

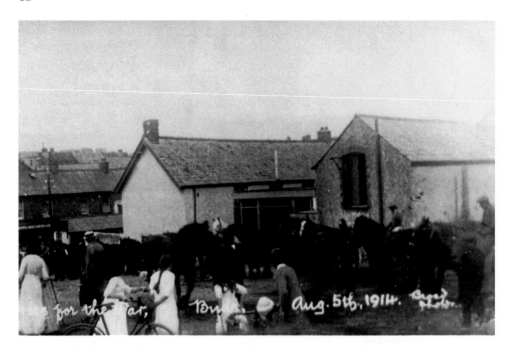

for the War, Bu... Aug. 5th, 1914.

Above: Bude horses gathered for shipping to the carnage of the First World War.

Left: Airship over Bude and Stratton (courtesy of Malcolm Mitchell).

MILITARY FUNERAL 1908

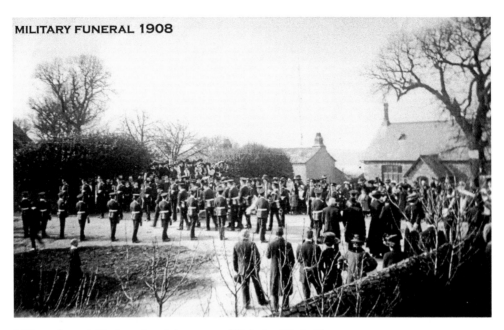

Military funeral, Marhamchurch (courtesy of Malcolm Mitchell).

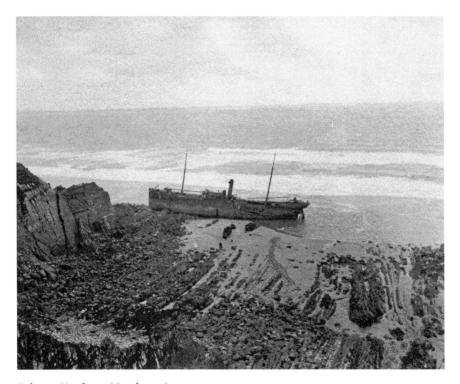

Belem at Northcott Mouth, 1916.

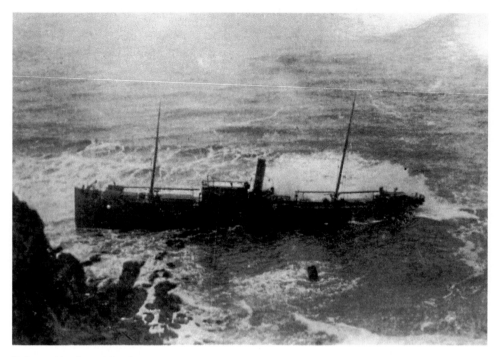

Belem at Northcott Mouth, 1917.

At the end of the war, Arthur saw the prisoners coming home to the railway station. A carriage would be there for them, and schoolboys and other locals acted as horses to pull them up along the Strand and Belle Vue, which he remembered as a great event. At age 107, Arthur was still chatting, so he had obviously had a long and healthy life.

Smugglers Cave and Pillbox

Bude's rugged cliffs, made of folded rock, are dramatic, but within them are many caves. At Northcott Mouth, one tunnel is said to run around a mile inland, which is said to have been used for storing smugglers' contraband. Northcott is interesting for other reasons too, not least the dragons' teeth anti-tank obstacles and a pillbox.

Incidentally, the stretch of coast from Bude to Duckpool, designated a site of specific scientific interest (SSI), is part of the Bude Formation, which, according to the South West coast path website, was formed on what were ocean beds in the Carboniferous Period over 300 million years ago. This is what causes the dramatic patterns in the cliffs around these parts, home to numerous fossils such as ammonites and crustaceans. There are also old traces of human development on the downs, including burial mounds. Crooklets has some Second World War relics to look out for – gun emplacements and remains of rifle butts. During the latter years of the war, Bude was home to many American soldiers, but more importantly these days, it houses satellites belonging to GCHQ.

GCHQ

From Bude's beaches, you can't fail to see GCHQ's massive satellites. Indeed, when people tell me we live in a very safe part of the country, I always mention that we are probably high on the nuclear hit list simply because of the GCHQ surveillance station, which is one of the biggest bastions of secrecy in the country. Professor Richard Aldrich from Warwick University, in 2010, wrote the story of Britain's secret intelligence agency, GCHQ, which developed as a cover name for Bletchley Park in late 1939 and has been used ever since. Aldrich called GCHQ 'the last great British secret'. There's been a lot of debate about GCHQ and the role of Bude since the Edward Snowden whistle-blowing revelations, but the area is visible from most parts of the coast around Bude. Incidentally, the married quarters that once existed at GCHQ were emptied and disposed of; auctioned in London, they only attained £1.2 million, apparently for sixteen houses (£75k each) so that was a bargain.

GCHQ is the stuff of surveillance and secrecy on Cornwall's very doorstep and Aldrich had reputedly been carrying his mobile phone around in a lead box for some years while writing his book. From virtually any beach or highpoint in Bude, your line of vision is invariably drawn to the alarming yet beguiling white satellites between Morwenstow and Coombe. Take a ride out. Once near, high-security fences and CCTV cameras keep you very much out of the classified intelligence-gathering site, so it's hard to tell much just by looking at the place. The station comprises the familiar sight of twenty-one satellite antennae and dishes. Interestingly, the *Cornwall Guide*, aimed at attracting tourists, makes no mention of GCHQ at Morwenstow/Bude (like you could miss it!), preferring to focus on the eccentric opium-smoking reverend of yesteryear, Revd Hawker ... but then nor does it mention the three nearby wind turbines that mark the landscape ...

The GCHQ building is a listening station, so paranoia started to set in as I did my research to find out more about it. Would too many GCHQ Bude searches put me on a 'world's most wanted' list? Rather disappointingly, the only indication I got of any change at all were pop-ups offering to check my credit rating while suggesting I simultaneously play online poker. That said, something felt strange as I don't normally experience pop-ups and haven't done again since ... Only one thing is certain about the place: you can always get a very decent mobile phone signal at Morwenstow, which never seems to happen elsewhere in the rural hinterland.

GCHQ Bude has receiver dishes which can and do track and copy all communications passing through Western communication satellites. Aldrich suggested that Bude's 'Project Echelon' is comparable to Google alerts, which scans the internet for new additions. The difference is that this material is not put in the public domain. There have been serious issues raised about scanning and storing the private domain of communication, including questions pertaining to legitimate authority and accountability. It has been left to whistle-blowers to lead to any public information at all.

Professor Aldrich suggests that twenty-first-century intelligence is gathered by looking at 'core data', which means it is less about content than to whom, where and when a message is sent. As he explains: 'no one person can read 2.8 million emails a second. What do you do with all that stuff to ensure that the single email that contains vital intelligence

ends up on the Prime Minister's desk in real time?' Good point. Controversially, there have been accusations that individual privacy may be compromised by such surveillance activities, but there has been remarkably little concern actually expressed by Joe Public, only by groups acting on Joe's behalf, such as, amazingly, the EU. Living in an age of public information sharing online through Facebook and Twitter, perhaps privacy is less important to us than it used to be. It seems that Professor Aldrich, who is obviously more in the know about such things than most of us, wanted to ensure privacy when writing his book. He thus used a 'dumb laptop', unconnected to the internet, which is unthinkable for most people requiring 24/7 access to the world wide web, to be 'in touch' or 'connected' at whim.

Should we be concerned that the Government may potentially know so much about us? Or should we be equally concerned that Google does? Or Tesco? Or the man or woman down the road? Do we care? We probably should. The sheer volume of public material out there is a double-edged sword according to Richard Aldrich, offering great opportunities for surveillance but also providing a real challenge to intelligence gathering through its sheer volume. And it is the sheer pace of changing technology, and how GCHQ deals with it, which adds extra interest to the subject. It seems that here in beautiful Bude, we have one of the UK's three main intelligence agencies (the others being MI5 and MI6). Bude GCHQ can theoretically cover all major frequency bands, and casts its net wide; it has recently been insinuated in intelligence gathering regarding Wikileaks, according to the Secret Bases website. The EU once expressed concern that it may have been engaged in industrial espionage, and did what one always does in such situations – commissioned a report which is fascinating reading (well, in parts).

What do we know? Very little, it seems, which is why Professor Richard Aldrich's book makes for some captivating reading for all who live in and around the area, are treated to a daily sighting of GCHQ Bude, or for those who just want to know what's going on in those secret spaces.

7. The Canal

The sea canal is now a major part of Bude's heritage. Originally planned to connect the Tamar, the original project was abandoned as economically unattractive. The canal idea popped into and out of favour for many years until 1819. By 1814/15, after the Napoleonic Wars, labour was very cheap and available, so a group of entrepreneurs revived the idea. In 1811, the Acland inheritance was taken over by Sir Thomas Acland, and various noteworthy people, including Lord Stanhope, invested in the idea of a canal, not to connect with the Tamar but to serve inland farms with sand from the beach. Edmund Leach was the man to suggest a series of inclined planes with 'mechanical hydraulic machines' to move barges from one level to another for transporting goods, which makes Bude canal pretty unique. The idea was first used by the Egyptians on the Nile. Instead of locks (there was not enough water and the land was too steep), the planes were designed by James Green, a civil engineer born in Birmingham (at last I have a connection, it being my birth city). He worked on the canal from 1819–25 after presenting a report on the combination of locks and inclined planes in 1818. The planes had rail tracks which accommodated the wheels on the boats to tackle the steep inclines. Bude's was the longest tub-boat canal in Britain. The barges were used to carry sand for fertiliser inland, but also to carry coal, agricultural produce and timber. The plan involved a 19-feet-wide canal with inclined planes and a breakwater to stand 10 feet above the spring tides, thereby connecting Chapel Rock with the mainland. The River Neet channel was altered and a sea lock built.

The first inclined plane from Hele Bridge to Marhamchurch was powered by a waterwheel. It was 120ft vertical and 830ft long. The canal was eventually killed off by a combination of the railway and chemical fertilisers, so was rather short-lived. Throughout the eighteenth century the passage around Land's End for coal had been a very dodgy and treacherous one, with many ships lost en route. The entrepreneurs saw a business opportunity. They could take huge quantities of sand inland and also carry other goods in and out. Remember, this was at a time when communications were isolated and roads were mere tracks. I'm told there is a Blake painting called *The Road From Bude to Bideford* showing a donkey with panniers, indicating the state of the tracks on main routes. I have not been able to find it but can imagine the state of the tracks.

Anne Longley is co-ordinator of volunteers at the Bude Heritage Centre archives (Bude Castle). Anne has a great interest in, and knowledge of, everything to do with Bude, despite its shortage of pre-1800s history. In 1800 she suggests, 'there was virtually nothing here. Bude wouldn't exist at all if not for the Canal, and the later Victorian passion for sea-bathing. Without that, after the closure of the Canal, Bude would have disintegrated.'

I'm not sure if she'd be classified as an incomer or not, but Anne has good Bude credentials. Her prominent great-grandfather ran a successful shipping company in the town. She lived here for five years as a child before her family moved to Southampton;

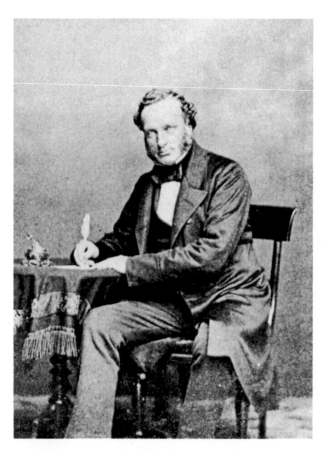

George Casebourne, Bude canal engineer.

A39 Hele Bridge.

later she worked in London. In 2001 she moved back to Bude because she 'felt a sense of identity, who I was, where I belonged, where my roots were. It explained the dissatisfaction I had felt with everywhere else I'd lived – it was simply because nowhere else was Bude.' Certainly, lots of people can identify with that.

Sharing Anne's love of Bude, we discussed the idea that Bude has never really developed a strong sense of its own identity like many places, though maybe that is changing. Bude, for example, doesn't really have any one specific centre or focal point because of the way it grew. Maybe that is what makes it so open to incomers, and why, conversely, some people find it harder to settle here.

Bude's whole economy was originally based around the canal, and later the railway, which opened in 1898, brought sea-bathers to Bude. Bude railway station was situated on the outskirts of town, allegedly to please Stratton, but did not have many passenger services, although it was possible to get directly to London from the town. That said, in the final months the only service was to Okehampton, some 30 miles away (which in itself closed in 1972, leaving Exeter as the nearest railhead). How wonderful to be actually able to reach Bude by train from the rest of the country, or to get to the rest of the country without using buses or cars. In 1800, Bude would have been lucky to have 100 people living here, but people flocked in when the canal opened, as it meant easy shipping to Bristol and Wales, and therefore economic activity/work. When the canal closed, Bude would have crumbled except for the developing tourist trade. Interestingly, this developed a new economic role for women who began to let out rooms and run boarding houses – still caught up in the domestic sphere but now making money from it – a trend which has continued.

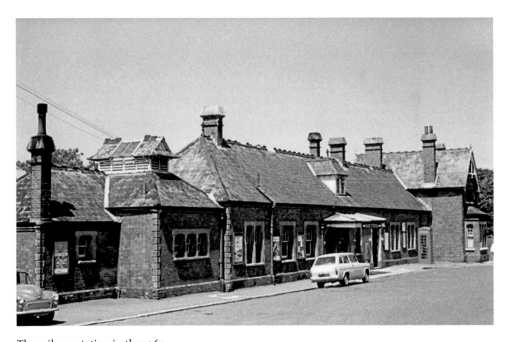

The railway station in the 1960s.

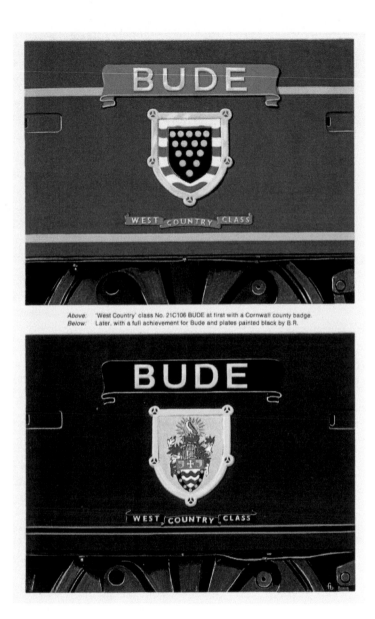

Above: 'West Country' class No. 21C106 BUDE at first with a Cornwall county badge.
Below: Later, with a full achievement for Bude and plates painted black by B.R.

Engine crest on the *Bude.*

The canal changed the topography in Bude. Victorian engineers built the breakwater and changed the course of the river to scour out a channel to create a makeshift harbour, both now part of the attraction of the town. They also built a big sea lock and, of course, the canal itself.

According to Anne, the quality of the materials available for these innovative engineers was not really up to the task they were asked to do, so there were frequent breakdowns, breakages and problems. Most profits made were actually used to simply keep the canal going until, eventually, the railway also added to the death of the canal, which had become expensive in upkeep and maintenance. The Bude Harbour & Canal Co. wound up in 1901 as the railway became more efficient and artificial fertilisers reduced the need for sand in agriculture. The local council however wanted a water supply for the town, as Bude was behind the times in only having a parish pump in 1901. So, it became responsible for the harbour/shipping trade and the canal. As you may imagine, the local politics of the time were colourful, reflected in the documents available at the archives.

There is plenty to discover from the Bude archives, which are open on Monday and Wednesday mornings. It helps to make an appointment to visit the archives so that people are available to assist, and also to have a clear idea of what you are looking for. There is a form available to request information if you don't live locally. As Anne says, the archives use the standard cataloguing system and the security of the records is stringent, so it is a resource worth maintaining. Meanwhile, a group of keen local historians and enthusiasts maintain the Bude Canal & Harbour Society Website, which is also well worth a look.

A spill on the iced Bude Canal, 1938.

8. Contemporary Bude

Bude is a wonderful town, but few visitors or locals are fully aware of the environmental activity here, so we finish off by changing tack and looking to the future. Starting with animals, Bude is rare in having water voles. Westland Countryside Stewards' Emma Cox explained that water voles (*Arvicola amphibius*) were once a common sight on our waterways but are now Britain's fastest declining mammal, due to loss of habitat and the spread of non-native American Mink in the 1980s and '90s. Voles are adapted to life in a water-edge environment where their swimming ability allows them to both forage effectively among semi-emergent plant life and to avoid predators by 'plopping' off the riverbank and swimming away. Conservationists have reintroduced them to Bude, which is, to date, the only place in Cornwall where you will see water voles in the wild. Water voles can be spotted throughout the River Neet/Stratt, the Bude Marshes and Bude canal. If you're short of time, the area around Hele Bridge is particularly active during their breeding season, from March until October. A female will produce 2–5 litters annually, each of 2–8 pups. Juveniles leave their mother after twenty-eight days and disperse from their natal territory throughout the summer and autumn. The typical lifespan of a water vole is around 5 months. Over-winter mortality rate can be up to 70 per cent as juveniles disperse. The American Mink is the main predator to the water vole, as the female mink will seek out colonies when hunting.

A water vole survey completed in 1989/90 recorded the highest density of mink in Cornwall in the Bude marshes and its wider catchment, likely due to the close proximity of a commercial mink farm near Bush. It is no wonder that the water vole quickly became extinct in these parts. The future of the water voles on the Bude catchment does require the support by active human intervention in the provision of a suitable habitat and to control predation by the non-native North American Mink. Westland Countryside Stewards proactively monitor and survey the catchment for the presence of mink to ensure the colony on the Bude catchment thrives.

Meanwhile, grey seals are always a beautiful sight and are seen in many places around Cornwall, including Bude, but there are threats to them, and they are regularly washed up on the beaches. Sue Sayer, of the Cornwall Seal Group, advises seals are very sensitive: 'If you come across one, to avoid disturbing seals on beaches from a clifftop, stand back out of sight and talk in whispers. If seals are hauled out offshore and look towards you repeatedly, you are already too close. If you continue to get closer, they will spook and rush to disappear into the sea, upsetting their energy and stress levels and possibly injuring themselves. If you are close to seals, move slowly and quietly. Watch their reactions, if they look at you repeatedly, back away quietly. Remember that seals can hear human voices – we sound very scary to seals, especially if we have loud, high-pitched voices.'

Water vole, Bude (courtesy of Westland Stewards, Kilkhampton).

Fishing net entanglement is a big problem for seals in Cornwall and the Isles of Scilly. Over 100 live seals have been seen with netting around their necks or bellies. A lot of net entanglement happens when seals play and swim over, under and into floating rafts of old, discarded or storm-damaged net. Seal pups have been seen to swim head first into clear plastic bags and be bashed around at high tide by plastic bottles, floating planks and oil drums. Older seals have been seen eating floating plastic bags, rubber gloves and crisp packets, so please dispose of all litter carefully. Cornwall Seal Group works with British Divers Marine Life Rescue and the Cornish Seal Sanctuary to help these animals. A number of seals have been washed up on Bude's shores, as reported by Ado Shorland of Widemouth Task Force. Marine litter is a huge problem, so Bude is lucky to have Widemouth Task Force, the Bude Cleaner Seas Project and Martin Dorey's Two Minute Beach Clean initiatives, which means regular beach-cleans, plus an ongoing educational process. Locals and visitors are welcome to get involved.

Whether you are keen on history, the mysterious, the literary or nature, Bude has lots of hidden places and facts for you to explore. Just treat the town and its shores kindly, and make sure you leave no litter behind! The phrase #lovewhereyoulive is sincerely believed here, in a place where locals live by the maxim #BigUpBude, a hashtag created by ethical PR founder Tracey Robinson, promoted by local taxi driver and advocate for Bude, Trev Plant, and illustrated here by website designer Dean Wronowski. It's no secret to locals but it may be to you; look out for it to keep in touch with Bude.

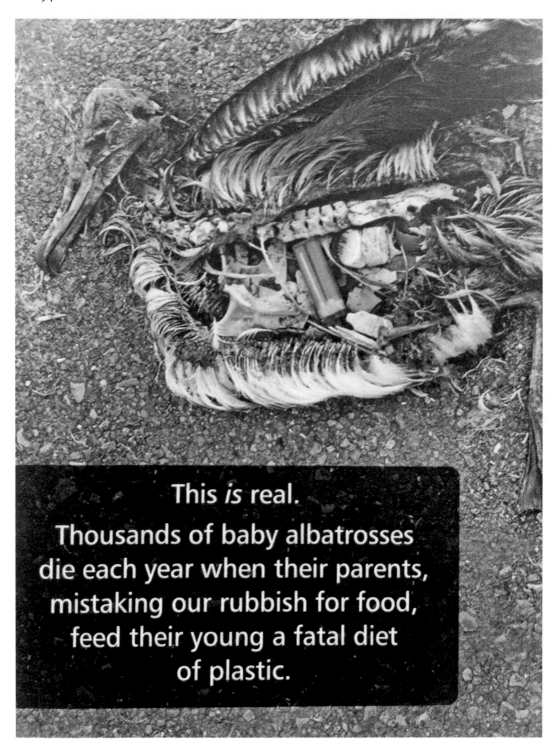

This *is* real.

Thousands of baby albatrosses
die each year when their parents,
mistaking our rubbish for food,
feed their young a fatal diet
of plastic.

Environmental damage, Heritage Centre, The Castle.

BigUpBude (courtesy of Dean Wronowski (designer) and Trev Plant).

References

A number of sources were used, many of which involved oral history or letters from private collections which cannot be referenced, but you may find some of these sources of interest.

'At Sea in a Blizzard: Bude Seaman Found Wrapped In The Mainsail', *Cornwall & Devon Post*

Dinshaw, Carolyn & Wallace, David, *The Cambridge Companion to Medieval Women's Writing*, Cambridge University Press, 2003

http://home.comcast.net/~pamela-c-smith/bio.html

http://muse.jhu.edu/journals/vp/summary/v040/40.2platizky.html

http://pcs2051.tripod.com/yeats.htm

http://www.encyclopedia-titanica.org/archie-jewell.html

http://www.encyclopedia-titanica.org/lookouts.html

http://www.independent.co.uk/sport/profile-the-big-noise-of-squash-jonah-barrington-owen-slot-studies-the-qualities-of-a-sporting-1376223.html

https://news.google.com/newspapers?nid=2507&dat=19890525&id=jjNAAAAAIBAJ&sjid=RlkMAAAAIBAJ&pg=6109,1123090&hl=en

'Plymouth Local History', *The Great Blizzard of March 1891*, Web. 14 Apr 2012

Port Isaac's Fisherman's Friends, *Fisherman's Friends: Sailing at Eight Bells*, 1 Sep 2011 (Kindle edition)

www.bernarddeacon.wordpress.com

www.bude-canal.co.uk/Tub%20Boat%20No%2048.pdf

www.cornwallsealgroup.co.uk

www.davidalton.net

www.encyclopedia-titanica.org/titanic-survivor/archie-jewell.html

www.freeman-morris-songs.com

www.helensburgh-heritage.co.uk

www.imagecollect.com

www.news.bbc.co.uk